Messages on
EDWARDIAN POSTCARDS

Glen

With love from

Freda.

Messages on
EDWARDIAN POSTCARDS

Freda Gittos

First Edition

ISBN: Paperback: 978-1-80227-351-9
eBook: 978-1-80227-352-6

CONTENTS

INTRODUCTION

Messages sent on Edwardian Postcards

Postcards in the Edwardian days were the main source of communication. In bigger cities, there were up to six deliveries per day. As can be seen in these messages, it was possible to send a postcard and know it would very likely be received the same day, and if sent locally, within hours. There were almost six billion postcards sent during the Edwardian era. The postal authorities even worked on Christmas Day, and consequently, there were many with a date stamp of 25th December.

Putting postcards into albums was a very popular collecting theme, with many sent by friends and family in order to boost personal collections. To stop the postman from reading personal messages, some senders resorted to mirror writing, semaphore and, very often, coded messages - some easy to de-code but others more complex.

Before 1902, a short message was allowed on the front of a postcard, but only the address on the reverse. In 1902, the Post Office altered the regulations to permit a message to be written on the left-hand side of the back. Most of the postcards manufactured were mass-produced, but many were privately commissioned.

To historians, the picture postcard represents an invaluable source of evidence for the period. Often the scenes shown on postcards do not exist in any other form.

Edwardian postcards were the equivalent of the digital communications that we see today.

ADVERTISING

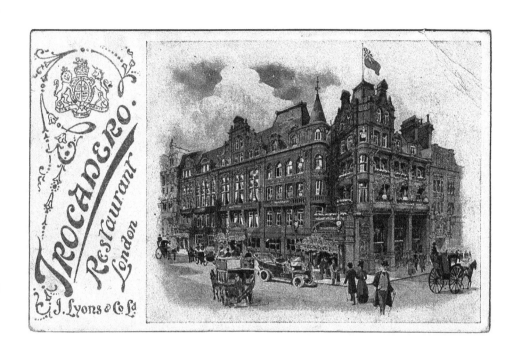

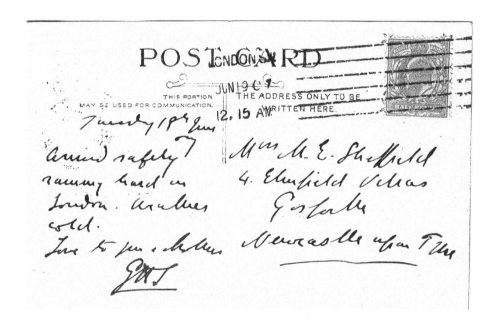

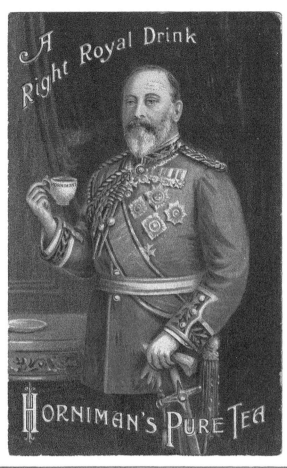

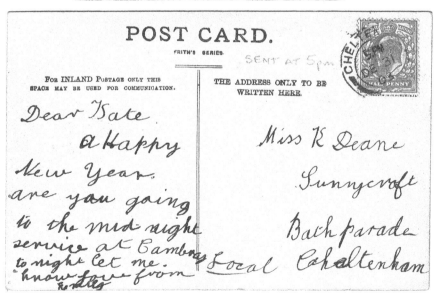

5

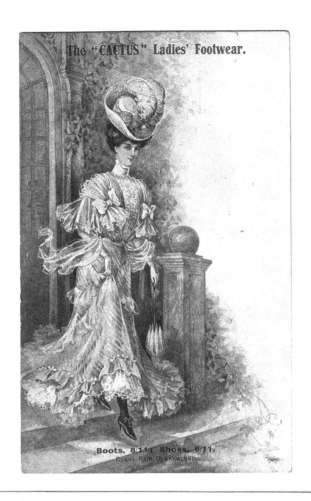

The "CACTUS" Ladies' Footwear.

Boots, 8/11; Shoes, 6/11.
Every Pair Guaranteed.

POST CARD.

Madam,

We have now received our new stock of the celebrated "Cactus" Boots and Shoes. This well-known brand is becoming a bye-word in every household.

Stylish up-to-date Boot 8/11, Shoe 6/11. Every Pair Guaranteed.

Leather toes, will not Crease.

Call and view at :—

LANE'S BOOT STORES,
PERSHORE.

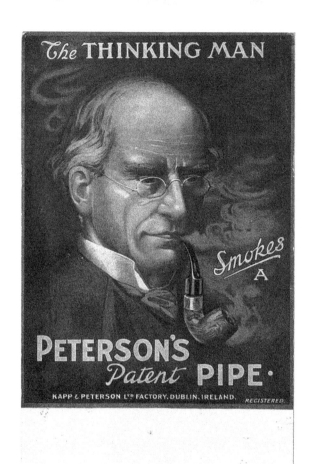

ART NOUVEAU

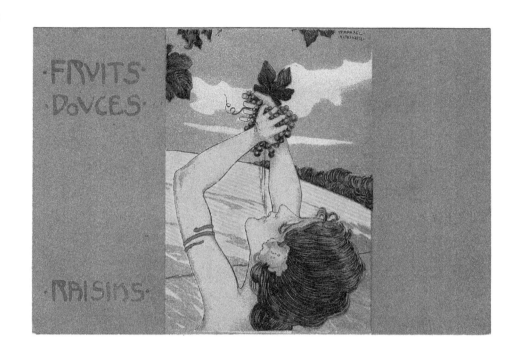

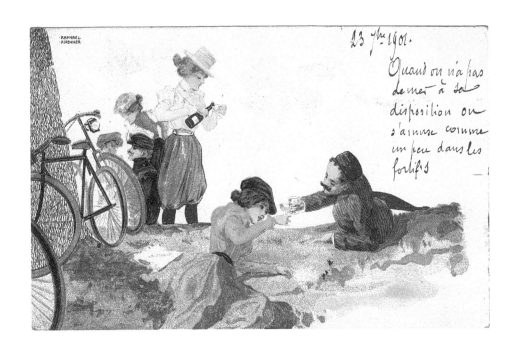

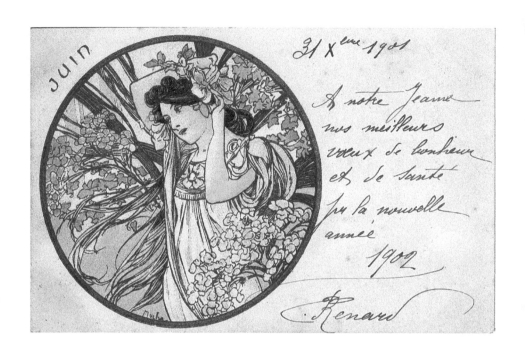

CHILDREN

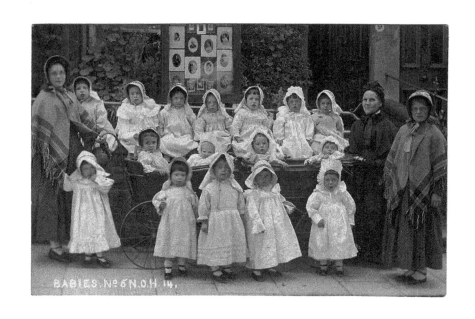

BABIES. Nº 5 N.C.H 14.

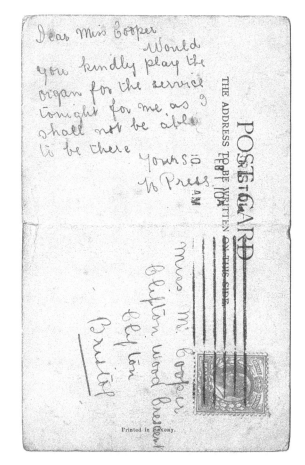

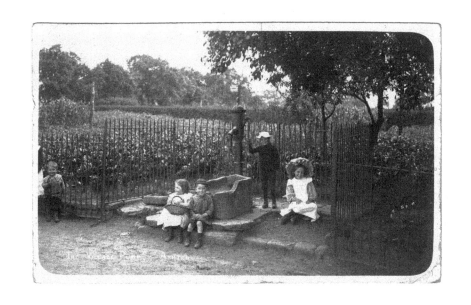

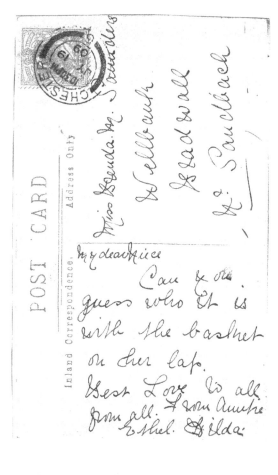

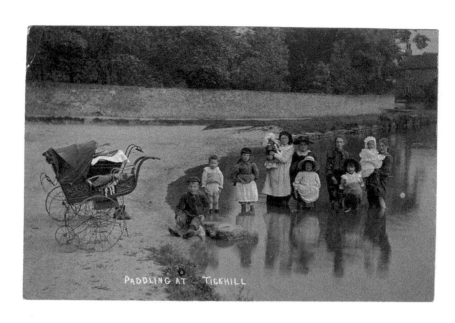

PADDLING AT TICKHILL

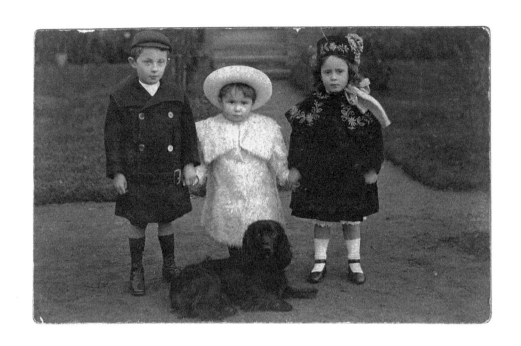

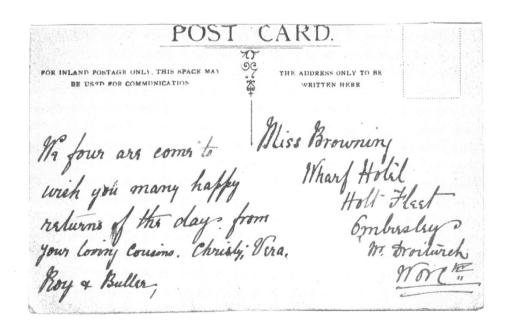

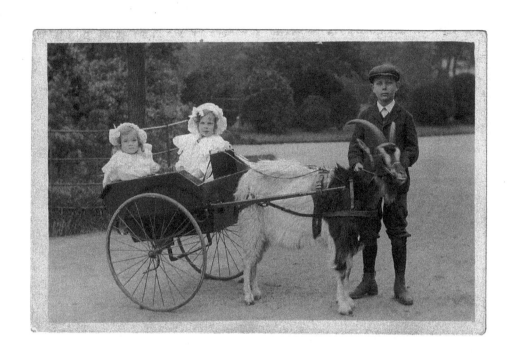

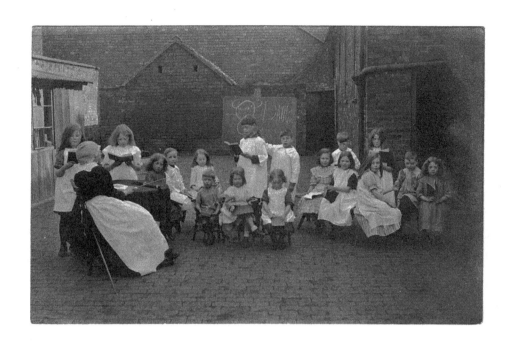

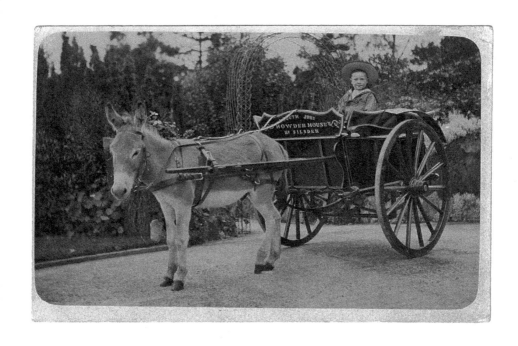

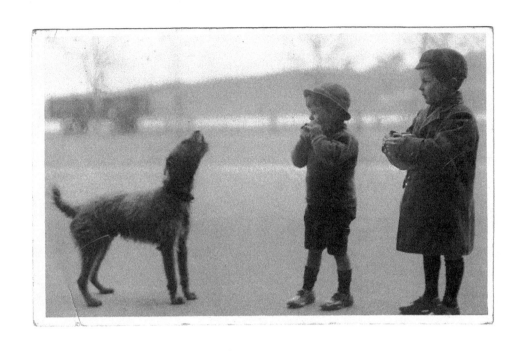

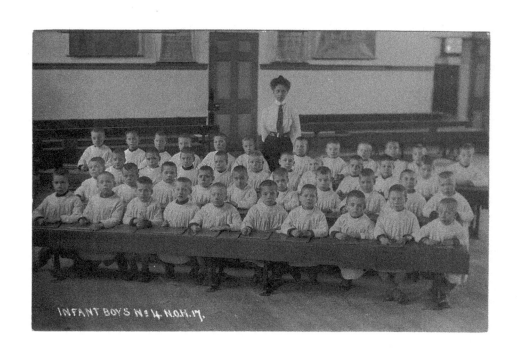

INFANT BOYS Nº 4. N.O.H. M.

POST : CARD

CORRESPONDENCE

ADDRESS ONLY

Dear Mama

come home

to me now

yours

Howard

56 Cliffton Rd

Weston super

Mare

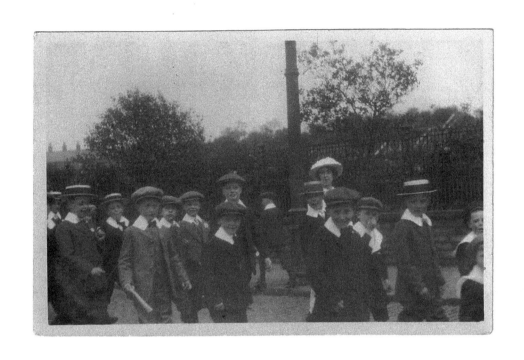

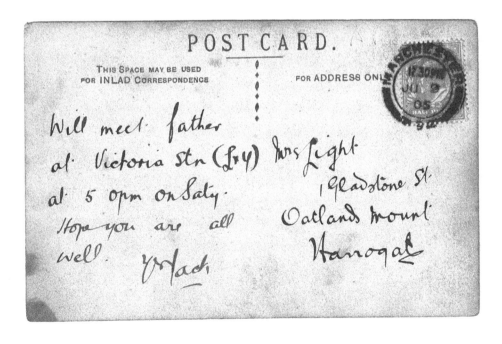

Will meet father
at Victoria Stn (L+Y)
at 5 0pm OnSaty.
Hope you are all
well.
YrJack

Mrs Light
1 Gladstone St.
Oatlands mount
Harrogate

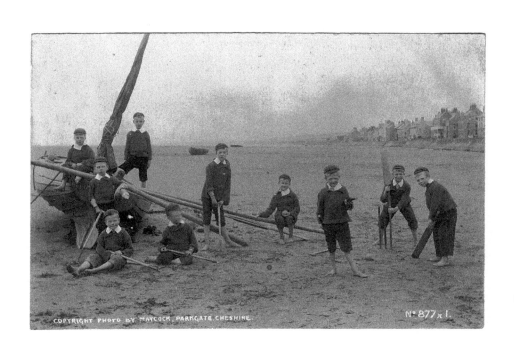

COPYRIGHT PHOTO BY MAYCOCK, PARKGATE, CHESHIRE.

Nº 877 x I.

POST CARD.

18 G

For Inland Communication only this
Space may be used

For Address only,

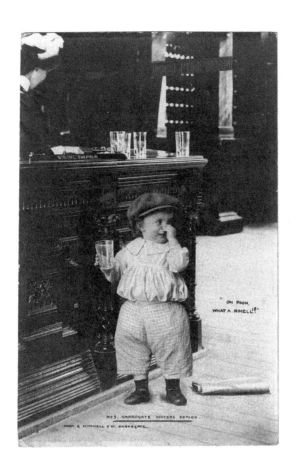

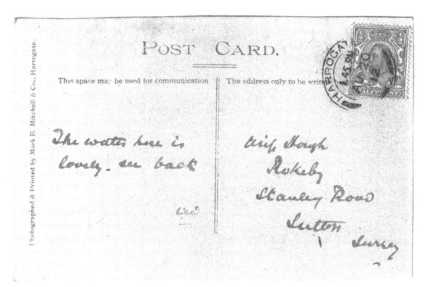

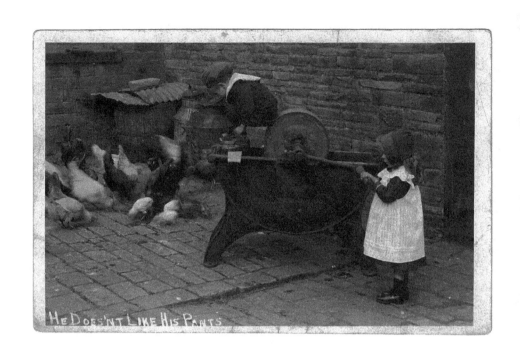

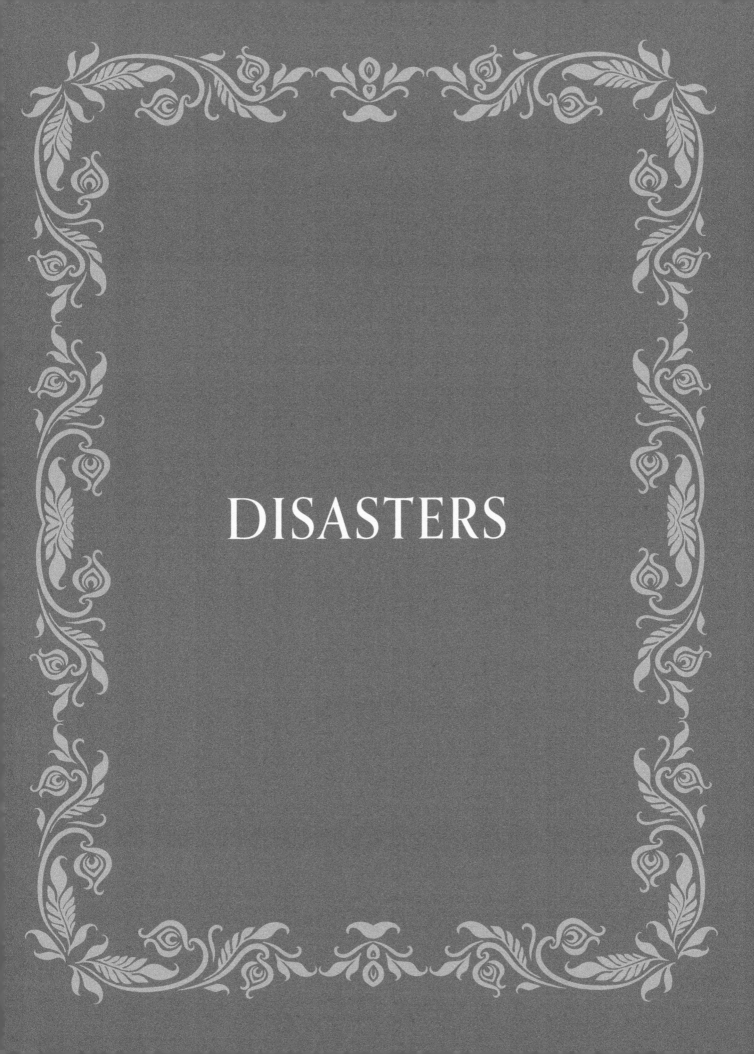

DISASTERS

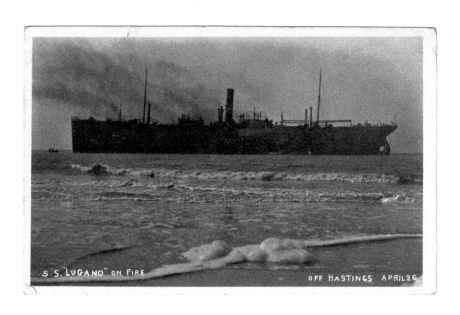

S.S. "LUGANO" ON FIRE OFF HASTINGS APRIL 26

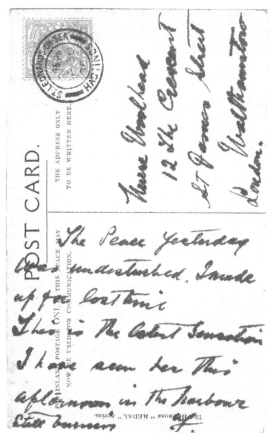

28

The Unwarrantable Attack on British Steam Trawlers, in the North Sea, by Russian Gunboats during Friday night Oct. 21st, 1904.

Hole made in galley of the "Moulmein" by Russian Shell. The Shell entered the other side of galley as shown in No. 6 of this series.

T.G.H. SERIES 1. NO, 5.
PHOTO. HICKINGBOTHAM.
LINCOLN.

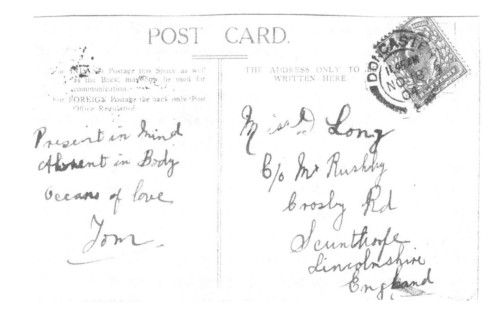

POST CARD.

For INLAND Postage this Space as well as the Back, may now be used for communication.
For FOREIGN Postage the back only (Post Office Regulation

THE ADDRESS ONLY TO BE WRITTEN HERE

Present in Mind
Absent in Body
Oceans of love
Tom

Miss D Long
C/o Mr Rushby
Crosby Rd
Scunthorpe
Lincolnshire
England

29

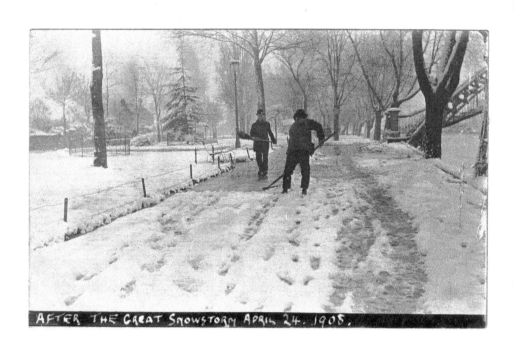

AFTER THE GREAT SNOWSTORM APRIL 24. 1908.

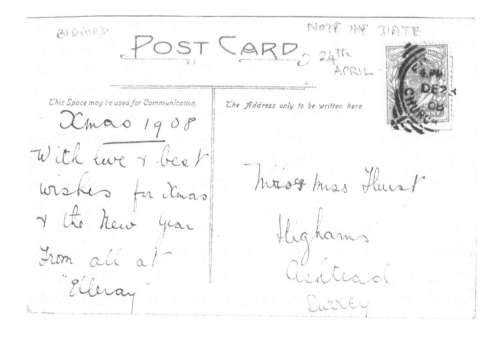

30

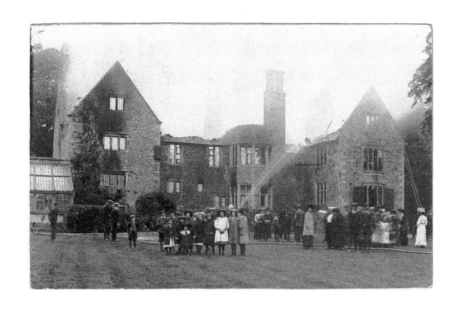

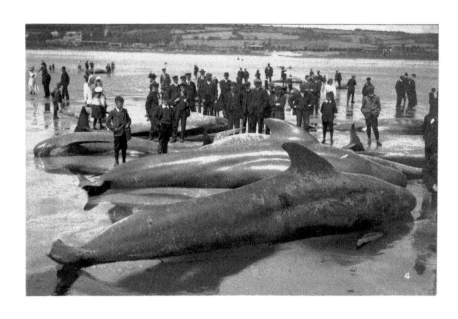

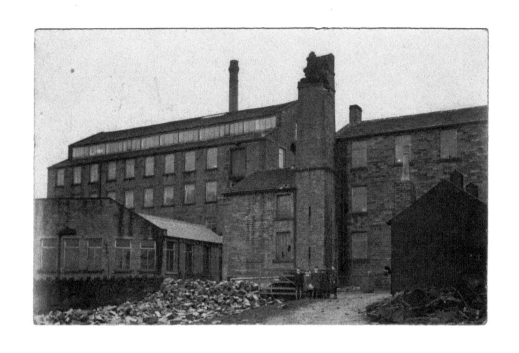

POST CARD

CORRESPONDENCE ADDRESS

The Day the Mill Chimney came
down after a severe gale, just
missing the Doctor's car returning after
his rounds.

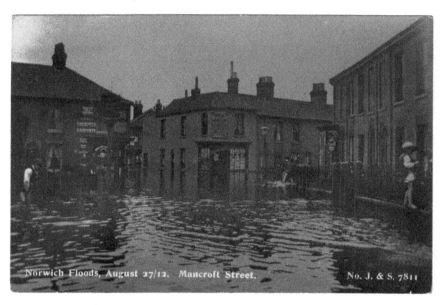

Dear Flo,

Thought I would send you P.C. of the Flood think they are nice to keep for your album. I feel a little better and am taking Cod Liver Oil. Dad has had a awful night, and he is very weak, think it is wicked to see him suffer like this, Dad sends his love, and he is always talking about you, Don't think I send you this card for you to answer so you have got so many to write too. With Love.

X Jessie X X

POST CARD

The Address only to be Written Here.

Miss Freda Ayhell
C/o MacAroy.
Drapers,
East Street
Southampton

34

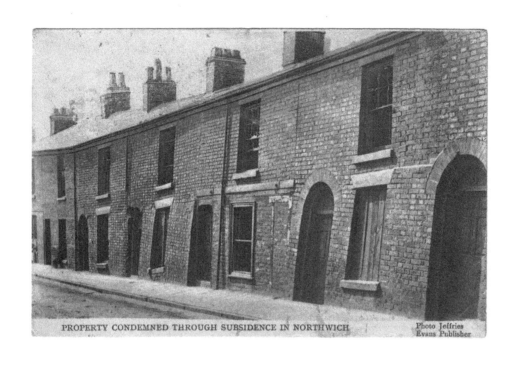

PROPERTY CONDEMNED THROUGH SUBSIDENCE IN NORTHWICH

Photo Jeffries
Evans Publisher

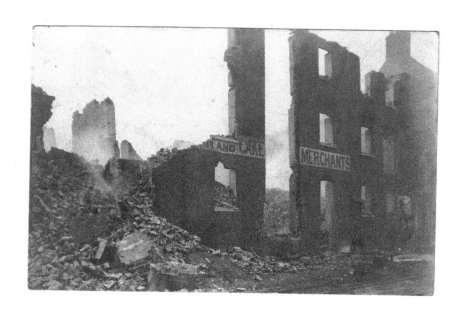

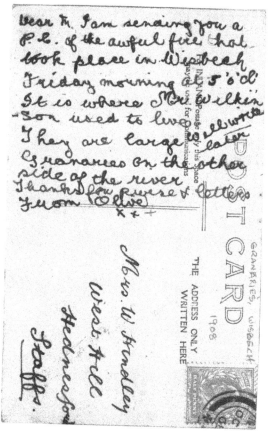

Dear ... I am sending you a
P.C. of the awful fire that
took place in Wisbeach
Friday mourning at 5 o'cl'
It is where Mr. Wilkin
-son used to live ... well write
They are large ... later
Granaries on the other
side of the river
Thanks for purse & letters
From Olive
× +

GRANARIES, WISBECH
1908

POST CARD
THE ADDRESS ONLY
WRITTEN HERE

Mrs. W. Hindley
West Hill
Hednesford
Staffs.

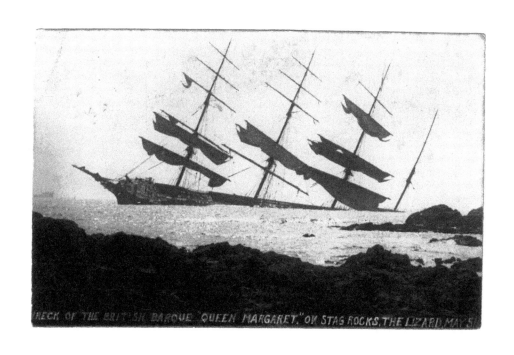

WRECK OF THE BRITISH BARQUE "QUEEN MARGARET" ON STAG ROCKS, THE LIZARD, MAY 5

The Cornish Riviera Series.

POST CARD

PUBLISHED BY E. A. BRAGG, 1, CLAREMONT TERRACE, FALMOUTH.

For Communication.

We are having a lovely
time here the weather
is perfect. This is
a wreck that we saw
on a trip in the Steamer
yesterday the Masts are
still showing just above
the Seas love to all From Auntie

Address Only

Mastr H.H.C. Newcombe
36 Devonshire Rd
Walthamstow
London

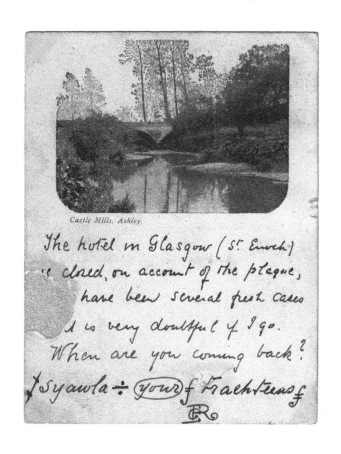

Castle Mills, Ashley.

The hotel in Glasgow (S⁺ Enoch)
is closed, on account of the plague,
there have been several fresh cases
it is very doubtful if I go.
When are you coming back?

Jsyawla ÷ (your) of Fraehteeasf

POST CARD.

Miss. E . Glazebrook Rylands
Erin Port
Holland Road
Liscard
Cheshire

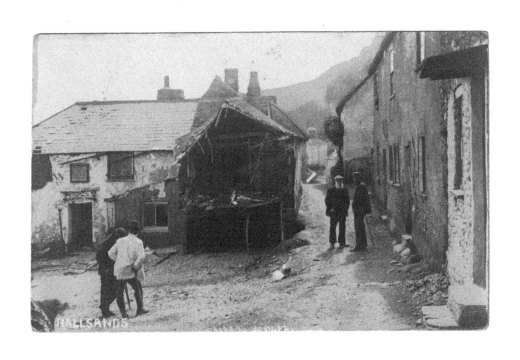

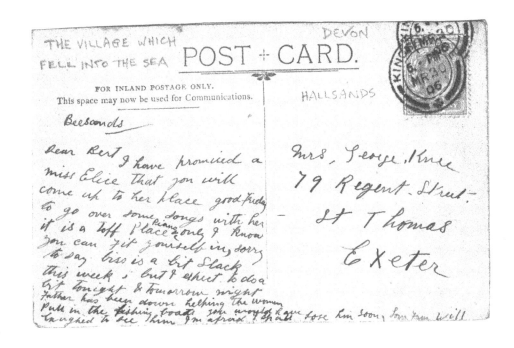

39

INDUSTRIAL

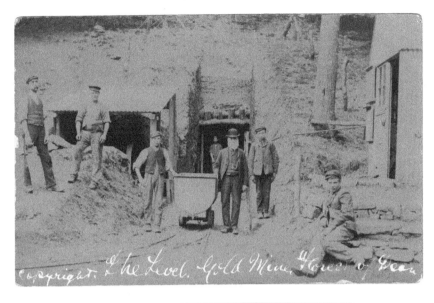

Copyright. The Level. Gold Mine, Forest of Dean

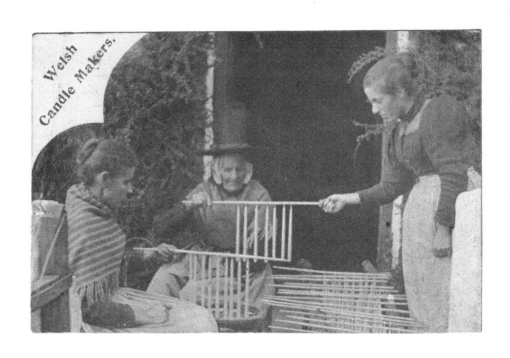

Welsh Candle Makers.

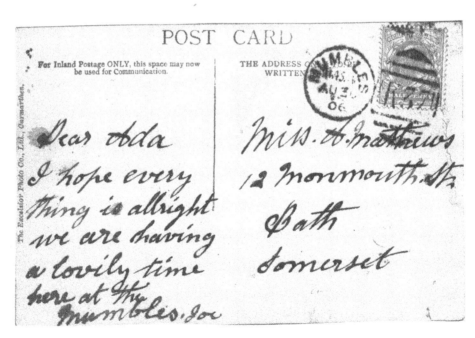

POST CARD

For Inland Postage ONLY, this space may now be used for Communication.

THE ADDRESS ONLY TO BE WRITTEN HERE

Dear Ada
I hope every
thing is allright
we are having
a lovily time
here at the
Mumbles. Joe

Miss A. Mathews
12 Monmouth St.
Bath
Somerset

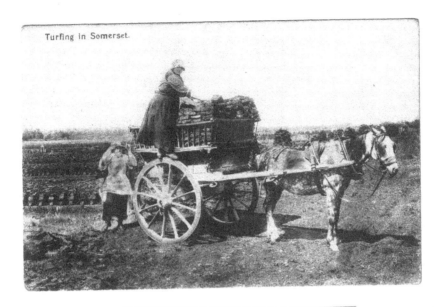

Turfing in Somerset.

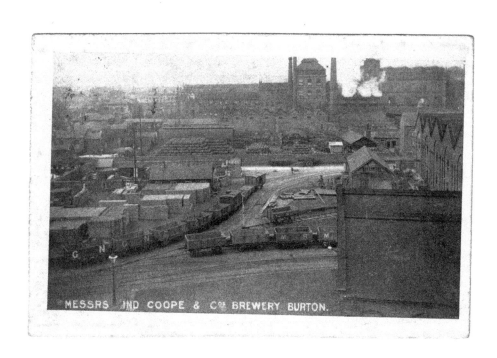

MESSRS. IND COOPE & Cᵒˢ BREWERY BURTON.

PICTORIAL POST CARD.

This Space, as well as the Back, may
be used for Communication.

The Address ONLY
to be written here.

Dear Annie·

This is one
of the places that
causes so much
sin & misery, so
many wretched
homes and halfclad
children·

Annie·

Miss Killingbeck

15 Dundee Lane

Ramsbottom

STOCKPORT
11 AM
AP 27
08

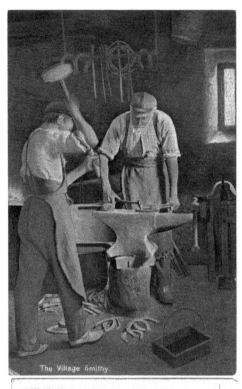

The Village Smithy.

Miss. D. Faraday
303 Rawlinson St
Barrow.
Local.

Dear Daughter We wish you many
happy returns of the day & hope
you may have as much luck
as there are horse-shoes on t'other
side. Don't you feel old? You
ought to do with love from
Father & Mother.

45

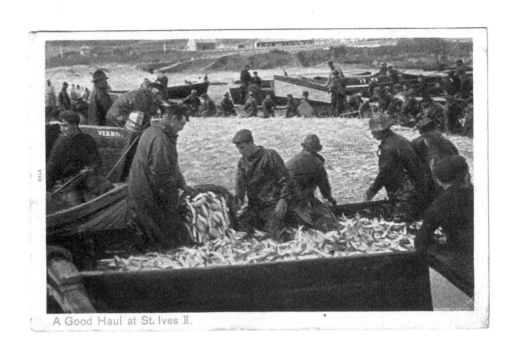

A Good Haul at St. Ives II.

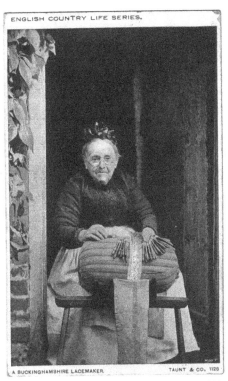

ENGLISH COUNTRY LIFE SERIES.

A BUCKINGHAMSHIRE LACEMAKER. TAUNT & CO, 1126

THIS SCENE CAN ALSO BE HAD AS AN 8 X 6 PHOTOGRAPH.

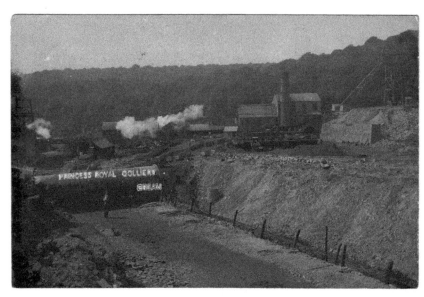

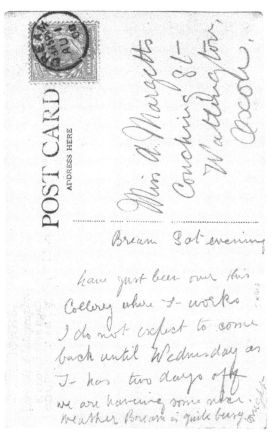

POSTCARD
COLLECTING

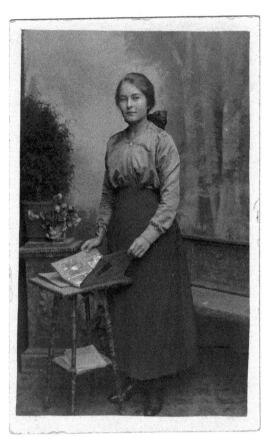

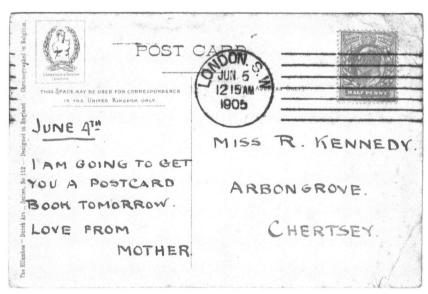

POST CARD

LONDON. S.W.
JUN 5
12 15 AM
1905

THIS SPACE MAY BE USED FOR CORRESPONDENCE
IN THE UNITED KINGDOM ONLY.

HALF PENNY

JUNE 4TH

I AM GOING TO GET
YOU A POSTCARD
BOOK TOMORROW.
LOVE FROM
MOTHER.

MISS R. KENNEDY.

ARBON GROVE.

CHERTSEY.

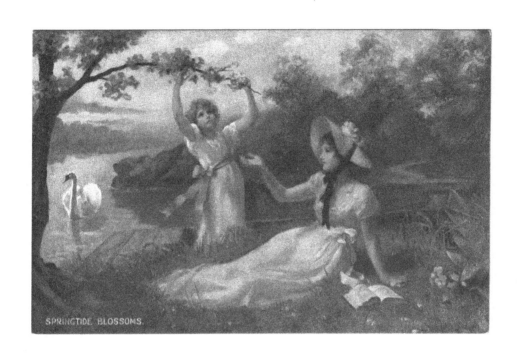

SPRINGTIDE BLOSSOMS.

TUCK'S POST CARD

CARTE POSTALE. LONDON

FOR ADDRESS ONLY.

DEC 28 06
8 45 M

Please help the Convalescent
Home, Crown Hill, Devon
by buying a packet of six
Tucks Postcards and contribute
to the Postcard chain for
the above Institution; to help
it to £1,000 Prize and £50
for yourself. Post the cards
according to rules supplied
free by all Dealers
 Yours
 Lily

Miss Dexter.
1 Brandreth Rd
Higher Compton
Plymouth

Printed in England.

51

107 Z MR. LEWIS WALLER. ROTARY PHOTO. E.C.

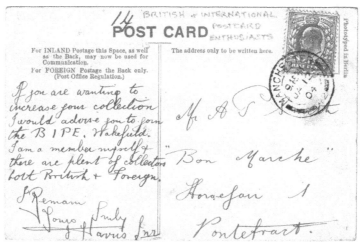

POST CARD

BRITISH & INTERNATIONAL POSTCARD ENTHUSIASTS

For INLAND Postage this Space, as well as the Back, may now be used for Communication.
For FOREIGN Postage the Back only.
(Post Office Regulation.)

The address only to be written here.

If you are wanting to increase your collection I would advise you to join the B I P E. Wakefield. I am a member myself & there are plenty of collectors both British & Foreign.

I Remain
Yours Truly
Harris Snr

Mr A T [?]

"Bon Marche"

Horsefair 1

Pontefract.

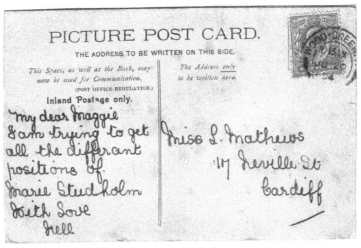

PICTURE POST CARD.

THE ADDRESS TO BE WRITTEN ON THIS SIDE.

This Space, as well as the Back, may now be used for Communication.
(POST OFFICE REGULATION.)

Inland Postage only.

The Address only to be written here.

My dear Maggie
I am trying to get all the different positions of Marie Studholm
With love
Nell

Miss L. Mathews
17 Neville St
Cardiff

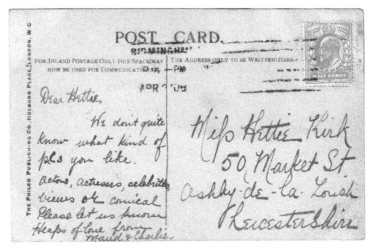

POST CARD

THE PHILCO PUBLISHING CO. HOLBORN PLACE, LONDON. W.C.

FOR INLAND POSTAGE ONLY THIS SPACE MAY NOW BE USED FOR COMMUNICATION

THE ADDRESS ONLY TO BE WRITTEN HERE.

Dear Hettie,
We don't quite know what kind of pks you like. Actors, Actresses, celebrities views or comical Please let us know Heaps of love from
Maud & Charlie.

Miss Hettie Kirk
50 Market St.
Ashby-de-la-Zouch
Leicestershire

POST CARD.

THIS PART MAY BE USED
FOR CORRESPONDENCE
FOR INLAND USE ONLY.

ADDRESS TO BE WRITTEN HERE.

a very big collection. I have
a great many p.p. cs I haven't
counted them for some time but
it was a lot over 1000 last time I
did. I hope you are quite well
With much love from
your loving little friend
Annie Fullerton

Miss Grace Sutton
Harrietsham.
near Maidstone.
Kent.

POST CARD.

For POSTAGE, IN THE UNITED KINGDOM ONLY.
THIS SPACE MAY BE USED FOR CORRESPONDENCE.

(FOR ADDRESS ONLY.)

Dear Gertie,
I hereby beg to
remind you that my
collection of postcards is
growing very slowly. It
now consists of six. Small
contributions thankfully
received.
Yours v. sincerely,
Jack.

14.11.34.

Miss Gertie Collingridge,
Victoria Villa,
21 Campfort Road,
Crouch End,
N.

POST CARD

For INLAND Postage only
this space may be used for
communication.

The ADDRESS only to be
written here

A
half-penny
stamp to be
placed here.

Dear Lil
Will you tell
mam I am only
sending postcards
to those who
have albums. will
send mam and
dad a letter on
Florrie

Miss L Chesterton
21 Dudley Rd
Grantham

ROMANCE

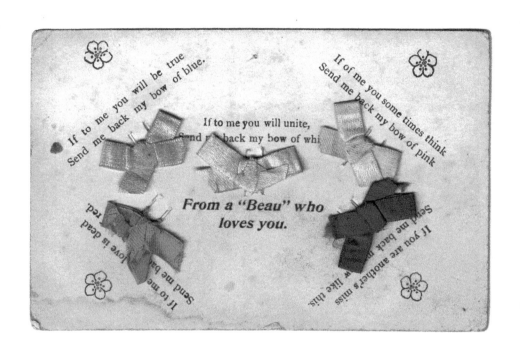

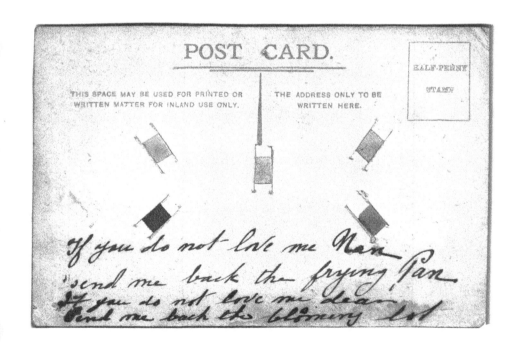

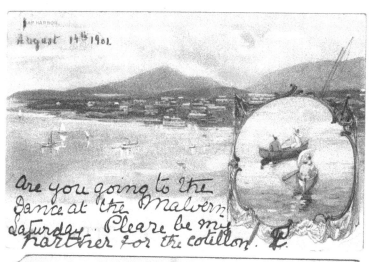

BAR HARBOR.

August 14th 1901

Are you going to the
Dance at the Malvern
Saturday. Please be my
Partner for the cotillon. F.

POST CARD.

This beautiful Series of Fine Art Post Cards is supplied free
exclusively by Christian Novels Publishing Co.,
For pure reading matter "Christian Novels" is the World's best.

THIS SPACE MAY BE USED FOR
CORRESPONDENCE FOR INLAND POSTAGE ONLY.

THE ADDRESS ONLY MAY BE
WRITTEN HERE.

Dear Alice
 Will you meet
me at the end
of Rosedale Rd
at 7·30 to night
 Yours
 Jack H.
XXXX·

Miss Alice Hardwick
#09 Ecclesall Rd
Sheffield

POST CARD

THIS SPACE MAY BE USED FOR CORRESPONDENCE
IN ACCORDANCE WITH THE LATEST FEDERAL
POSTAL REGULATIONS.

WRITTEN HERE.

Stamp.

Printed
in Bavaria.

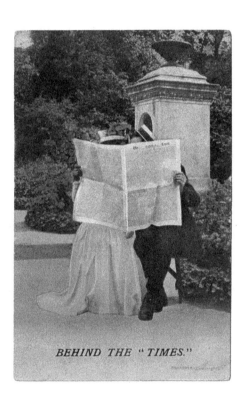

BEHIND THE " TIMES."

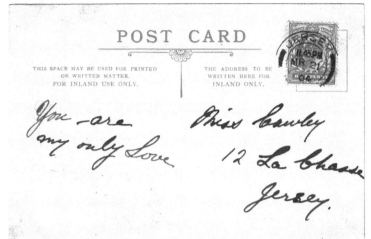

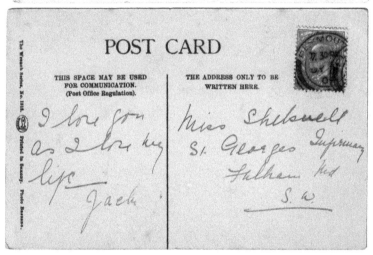

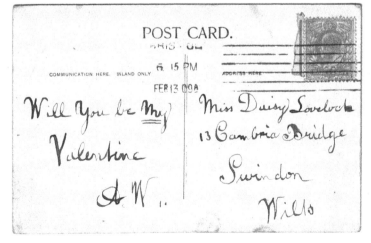

AMUSING

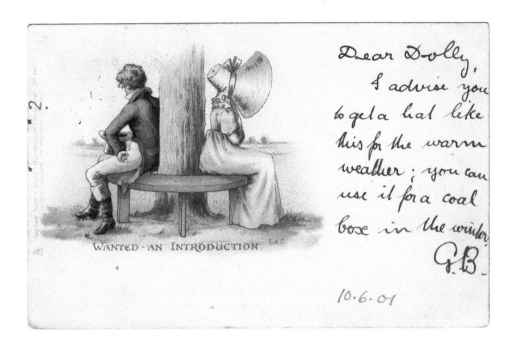

Dear Dolly,
 I advise you
to get a hat like
this for the warm
weather; you can
use it for a coal
box in the winter
 G.B.

10.6.01

WANTED - AN INTRODUCTION.

POST CARD.

THE ADDRESS TO BE WRITTEN ON THIS SIDE.

Miss Dolly Lord,
 Mrs Knott,
 Hunt Bridge House,
 Matlock Bridge.

61

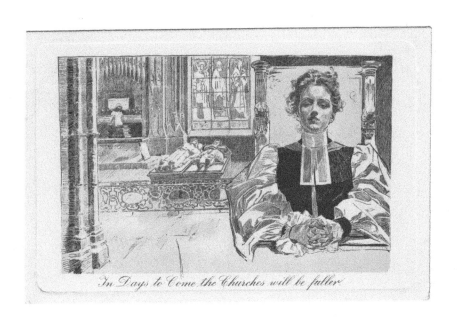

In Days to Come the Churches will be fuller

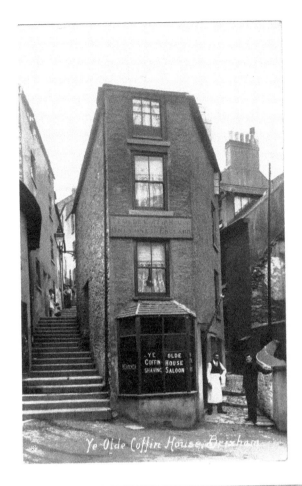

Ye Olde Coffin House, Brixham

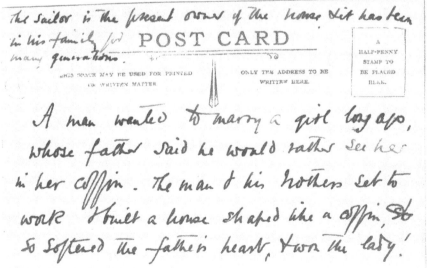

The sailor is the present owner of the house. It has been in his family for many generations.

A man wanted to marry a girl long ago, whose father said he would rather see her in her coffin. The man & his brothers set to work & built a house shaped like a coffin, & so softened the father's heart, & won the lady!

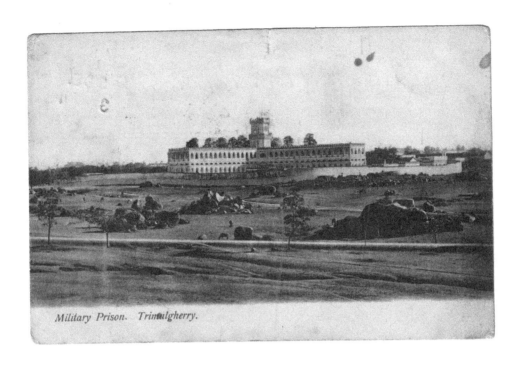

Military Prison. Trimulgherry.

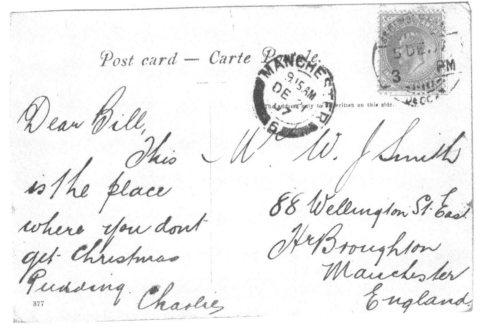

Post card — Carte Postale.

The address only to be written on this side.

Dear Bill,
 This
is the place
where you dont
get Christmas
Pudding. Charlie

377

W. W. J. Smith
88 Wellington St East.
Hr Broughton
Manchester
England.

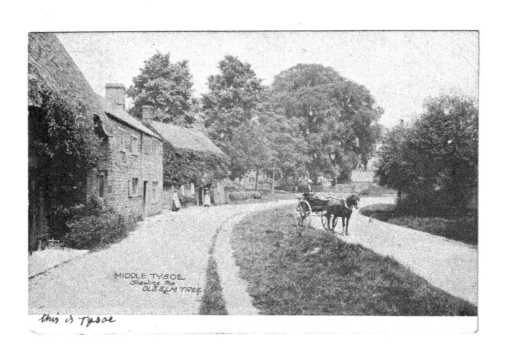

this is Tysoe

MIDDLE TYSOE.
Shewing the
OLD ELM TREE

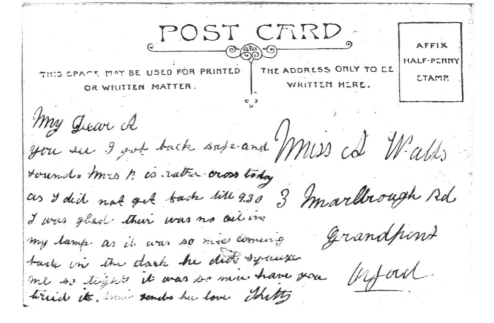

POST CARD

THIS SPACE MAY BE USED FOR PRINTED
OR WRITTEN MATTER.

THE ADDRESS ONLY TO BE
WRITTEN HERE.

AFFIX
HALF-PENNY
STAMP.

My Dear A
You see I got back safe and
found. Mrs B is rather cross today
as I did not get back till 9.30
I was glad their was no oil in
my lamp. as it was so nice coming
back in the dark he did squeeze
me so tight. it was so nice have you
tried it. ____ sends her love Thitty

Miss A Watts
3 Marlbrough Rd
Grandpont
Oxford

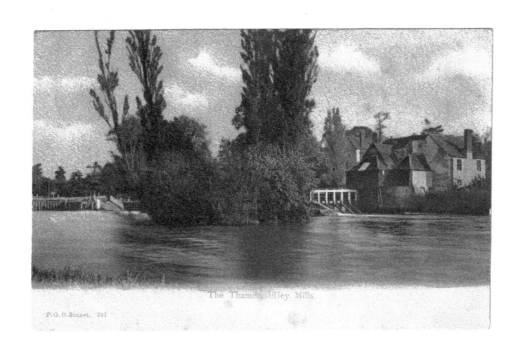

The Thames, Iffley Mills

F.G.O. Stuart. 891

POST CARD.

FOR INLAND POSTAGE ONLY, THIS SPACE
MAY BE USED FOR CORRESPONDENCE.

ADDRESS TO BE WRITTEN HERE.

Dear L.

What do you think
of this Mill, I went
to see it when I was
staying in Oxford, you
have to pay ½ to go over
the bridge, I have been
hard up ever since
R. H.

Miss L Hamblin
(Ivy House)
Gt Shefford
Lambourn
Berks

38480

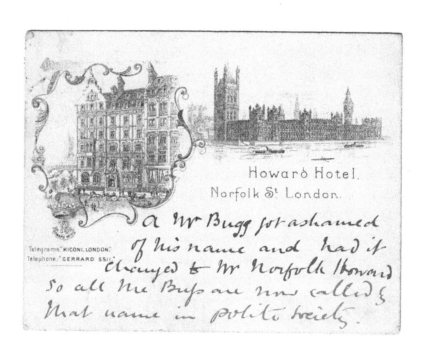

Howard Hotel.
Norfolk St London.

Telegrams "KICONI, LONDON."
Telephone "GERRARD 5511"

A Mr Bugg got ashamed of his name and had it changed to Mr Norfolk Howard so all the Bugs are now called by that name in polite society.

POST CARD.

THE ADDRESS ONLY TO BE WRITTEN ON THIS SIDE.

Miss Marjorie Fielding
The Lawn
Brunswick Rd
Gloucester

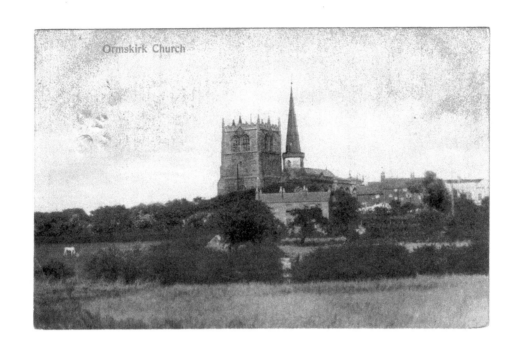
Ormskirk Church

POST CARD

This Space as well as the Back may be used for Inland Communication

(Post Office Regulation)

The Address only to be written here

Two Sisters
built this church
quarrelled – as
to Tower or Spire
they could not
agree. so it
has better as
a result.

434 Novelty Post Card Co., Liverpool

Mrs Elphie Brown
Linkfield House
Portobello
Edinburgh

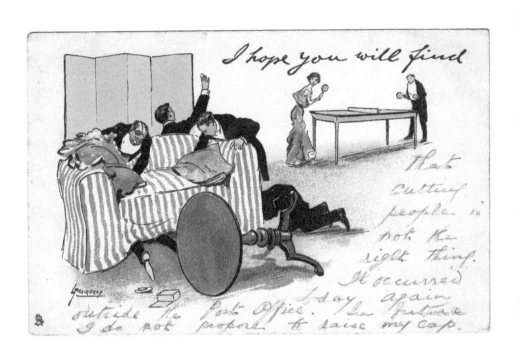

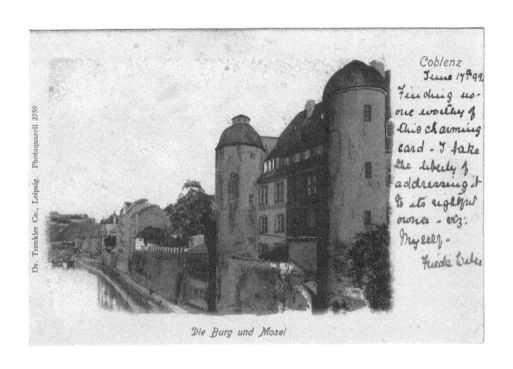

Miss Annie Imlah
Western Hotel
Penzance
Cornwall

Never trouble trouble
till trouble troubles
you
yours Alice

Postkarte — Carte postale
Weltpostverein — Union postale universelle
Levelezö-Lap — Correspondenzkarte — Dopisnice
Karta korespondencyjna — Korespondenční lístek
Briefkaart — Post card — Brevkort
Cartolina postale — Tarjeta postal
Открытое-письмо. ДОПИСНА КАРТА

Correspondence

Miss D Hammer
(otherwise) Mrs Roberts
Gepista
Hamilton Road
New Brighton

With love
From aunt Mara
"You've gone and
married him
after all I said
to you"

Serie 9

Dear Granny
 Just a line to
ask you if you would
send mother a new
pair of drawers because
hers are worn out
 love Leslie

POST CARD
CORRESPONDENCE
FOR ADDRESS ONLY

No 2.
Gentlemen a required as wet
nurse for ladies 14th baby.
Good tempered, must be sound
in body & mind — of clean
personal appearance, good
education & manners, of more
importance than a mere
Widower had. Night or day
work not objected to.
Companion for the mistress in
the Masters absence. No salary.
apply at the War Office.

POST CARD
POSTKARTE
(FOR ADDRESS ONLY)

Editor of The
Daily Express
St Brides St
London E.C.

Miss E Merriman
134 Waterloo Rd
Wolverhampton.

POSTCARD – GREAT BRITAIN & IRELAND

Writing Space for Inland Postage only.

Dear Em, I was expecting
to hear from you before
this, but I suppose you
are to busy, with courting
or working, to remember me,
But let me warn you, you will
be a great better off dead
than married to the old rogue
you brought here, not that
it is anything to do with me
whether you go to heaven or hell
but forewarned is forearmed &
you know that I represent heaven & Tom,—
well I'll remain yours, Pam, MIZPAH

POST CARD.

H. P. HANSEN, Photographer, Ashbourne

ADDRESS ONLY HERE.

This Space for Correspondence.

Miss R. R. Pitts.

Manor House
Ashby De La Touch
Leicestershire

Still of no
fixed abode

73

POST CARD.

THE ADDRESS ONLY TO BE WRITTEN HERE.

THIS SPACE MAY BE USED FOR COMMUNICATION IN THE BRITISH ISLES ONLY
(Post Office Regulation.)

A. Blake. Es.
48. Black St.
N Parliament sty Rd
Glasgow

Just going to
the Chemist
for Castor oil
just say when you
are ready for a
dose. E. P.

The Knight Series, No. 623. Printed in Saxony.

POST CARD

Mfs Chandler
Little Staughton
St Neots
Hunts

My Dear Teacher
I am so pleased to
write to you, but I
dont want to go
to school no
more now you
are gone from
Olive Ruff

POST CARD

THIS SPACE MAY BE USED FOR COMMUNICATION IN THE BRITISH ISLES ONLY. (Post Office Regulation).

The Wrench Series

Bloaters for tea

THE ADDRESS ONLY TO BE WRITTEN HERE.

Cart Horse
5, Heathville R?
Gloucester

POST ❖ CARD

G.W.W.

THE ADDRESS ONLY HERE.

Damp

Mr R Hailing
Oxford Passage
Cheltenham

POST CARD.

THIS SPACE, AS WELL AS THE BACK, MAY NOW BE USED FOR COMMUNICATION BUT FOR INLAND ONLY.

THE ADDRESS ONLY TO BE WRITTEN HERE.

Are you alive a-G-

Miss Bampton
Nunney Rectory
Frome

POST CARD.

THIS PART MAY BE USED
FOR CORRESPONDENCE
FOR INLAND USE ONLY.

ADDRESS TO BE WRITTEN HERE.

There was a young lady
of Niger
who went for a ride on
a tiger
They finished the ride
With the lady inside
And a smile on the
face of the tiger

Now's that ⚡

Mrs F. W. Davey
4 Elm Grove
Woodford Green
Essex

POST CARD

FOR INLAND USE ONLY
THIS SPACE MAY BE USED
FOR COMMUNICATION

THE ADDRESS ONLY
WRITTEN HERE

May you live
long & die
Happy

M. C.

Miss Lloyd
Theatre Royal
Belfast

Brandon House
Aust: Glos.

Post Card.

CORRESPONDENCE

Dear Mother I
am writting you
a p.c. I arived safe
when I got out of
the station I went
in a Brake. Will you
send on my pinnie for
because I fore got it
and she was very cross
because I did not have
none

ADDRESS

Mrs Taylor
2 Hanover St
Barton Hill
Bristol

POST CARD

THIS SPACE MAY BE USED FOR PRINTED
OR WRITTEN MATTER.
FOR INLAND USE ONLY.

THE ADDRESS TO BE
WRITTEN HERE FOR
INLAND ONLY.

Dont tell him
you love him.
it makes his
hair stand
on end.

Miss F. Cawley
12 La Chasse
Jersey

POST CARD.

The address to be written here.

One Fool makes
many This will catch
you for a penny
April 1st 1909

Miss F Dettmer
46 Senrab St
Stepney

POST CARD.

FOR POSTAGE, IN THE UNITED KINGDOM ONLY.
THIS SPACE MAY BE USED FOR CORRESPONDENCE.

(FOR ADDRESS ONLY.)

My Dear mother
You told
me to write something
about myself & I will say
I am about — , sallow
complexion dirty grey-yes
carroty hair. Size of hat
11·4. Size round waist
4 ft. round neck 3 ft.

Mrs E Judd
58 Roland Rd
Handsworth
Staffs

79

POST CARD

For INLAND Postage only this space may be used for Communication

The ADDRESS only to be written here

Copyright by The Novelty Post Card Co., Liverpool, No. 461

Dear Dick
I was so pleased
with your company
at London but was
sorry to find out
you was a married
man Yours ever Gerty

Mr R. Dent
19 · Birch St
Bury.
Lanc

POST CARD

Communication only

The address only to be written here

The Advance Series A P Co. B, No 152

Please go as soon as
possible to Mathews in
Bridge Street & he will
give you knickers &
also a belt if you
require it

W Pratt

James Burgess
116 Beacon Hill
NEWARK

POST CARD.

For INLAND Postage only this space may be used for communication.

The ADDRESS only to be written here

Charles Martin, London.

May I have the pleasure
of seeing you in school
to-morrow, as you have
not been for several
weeks.
With love, hoping you
are well from J. S. Phillips

Master Giffard
25 Leighton Grove
Brecknock Road.

80

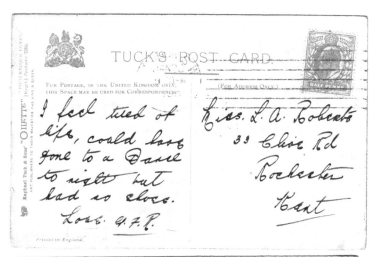

TUCK'S POST CARD

FOR POSTAGE, IN THE UNITED KINGDOM ONLY,
THIS SPACE MAY BE USED FOR CORRESPONDENCE.

(FOR ADDRESS ONLY)

I feel tired of
life, could have
gone to a Dance
to night but
had no shoes.
Love. A.F.P.

Miss. L. A. Roberts
33 Chive Rd
Rochester
Kent

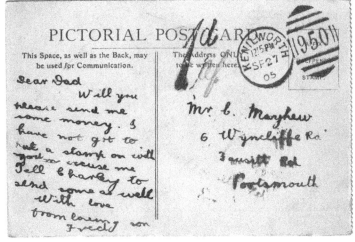

PICTORIAL POST CARD

This Space, as well as the Back, may
be used for Communication.

The Address ONLY
to be written here.

Dear Dad
 Will you
please send me
some money. I
have not got to
put a stamp on will
you excuse me
Tell Charley to
send some as well
 With love
 from loving son
 Fred

Mr C. Mayhew
6 Wyncliffe Rd
Fawcett Rd
Portsmouth

POST CARD

Have you started
work yet? If not
I'll come over & clout
you.
 Uncle

RURAL

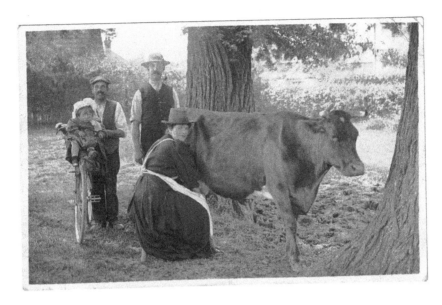

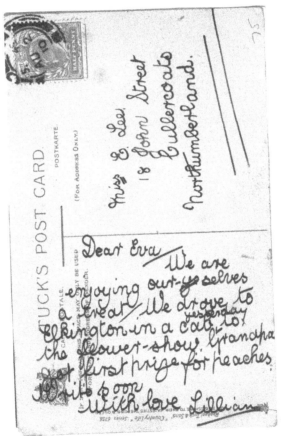

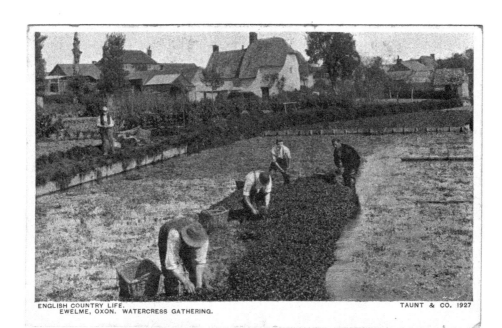

ENGLISH COUNTRY LIFE.
EWELME, OXON. WATERCRESS GATHERING.

TAUNT & CO. 1927

POST CARD.

THIS SPACE, AS WELL AS THE BACK, MAY
NOW BE USED FOR COMMUNICATION
BUT FOR INLAND ONLY.

THE ADDRESS ONLY
TO BE WRITTEN HERE

Please send
1 Sack of Barley
meal to-morrow
by cart. R Mayock
 Wendlebury

Mr Smith
Ambrosdon
 Mill
Nr Bicester
 Oxon

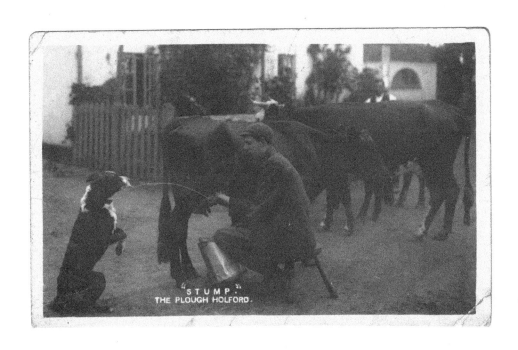

"STUMP."
THE PLOUGH HOLFORD.

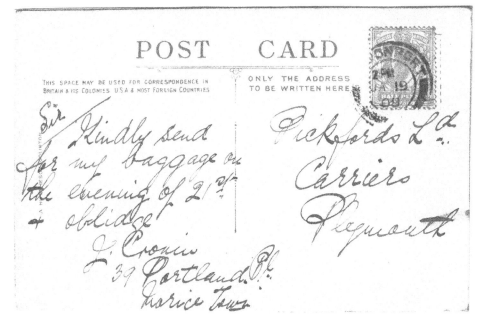

POST CARD

THIS SPACE MAY BE USED FOR CORRESPONDENCE IN
BRITAIN & ITS COLONIES U.S.A & MOST FOREIGN COUNTRIES

ONLY THE ADDRESS
TO BE WRITTEN HERE

Sir
Kindly send
for my baggage on
the evening of 21st
+ oblidge
J. Cronin
39 Portland Pl.
Morice Town

Pickfords Ld
Carriers
Plymouth

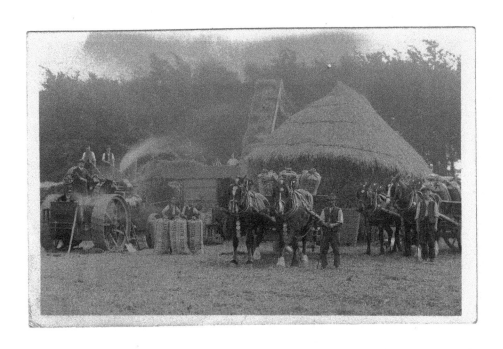

POST CARD. 1650

This space as well as back may
be used for communication.

The Address only to be written
here.

S. A. BUTLER,

Threshing Contractor,

Wheat 10ᵈ per sack

HATCHWARREN FARM,

BASINGSTOKE.

Threshing done at Lowest Prices.

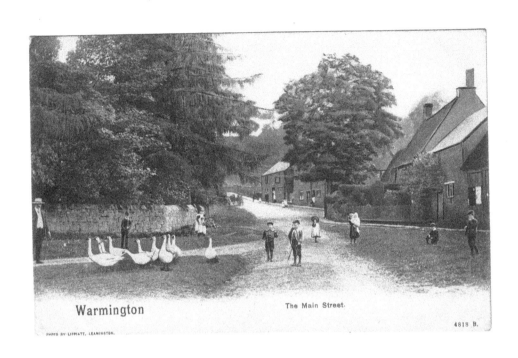

Warmington The Main Street.

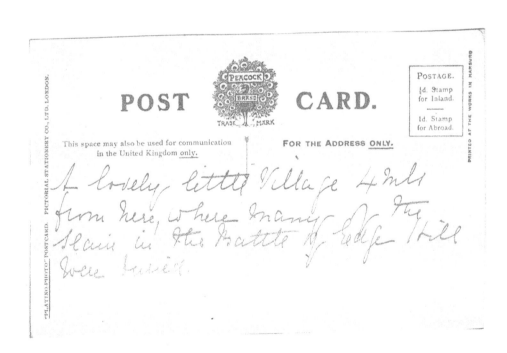

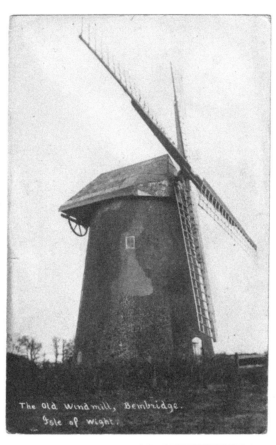

The Old Windmill, Bembridge.
Isle of Wight.

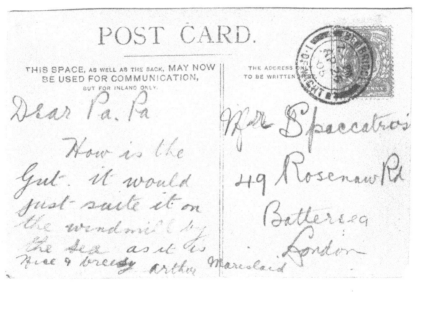

POST CARD.

THIS SPACE, AS WELL AS THE BACK, MAY NOW
BE USED FOR COMMUNICATION,
BUT FOR INLAND ONLY.

THE ADDRESS ONLY
TO BE WRITTEN HERE

Dear Pa. Pa

How is the
Gut. it would
just suite it on
the windmill by
the sea as it is
nice & breezy Arthur

Mrs Spaccatros
49 Rosenaw Rd
Battersea
London
Marislaid

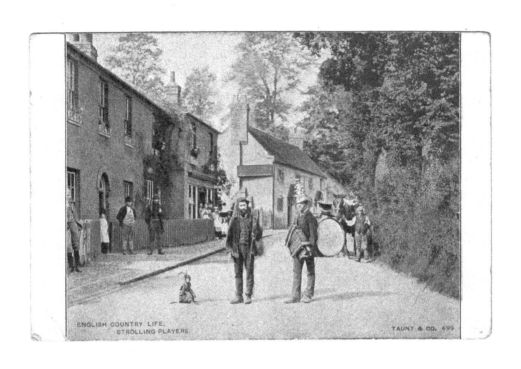

ENGLISH COUNTRY LIFE.
STROLLING PLAYERS.

TAUNT & CO. 499

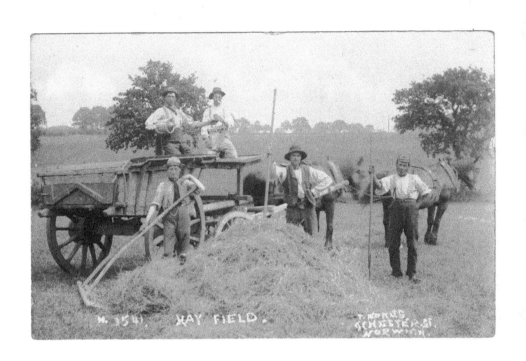

M. 1541. HAY FIELD. T. HORNES
 COLCHESTER Sr.
 NORWICH

POST CARD

For Communication. Address Only.

To Mother
 With Love From
 Ruth and Bert

What do you think of the carter

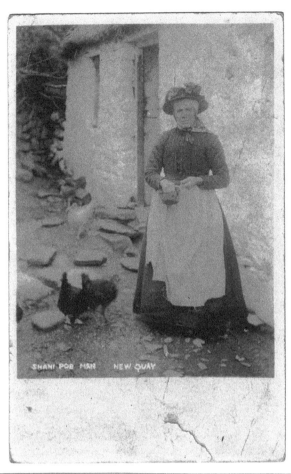

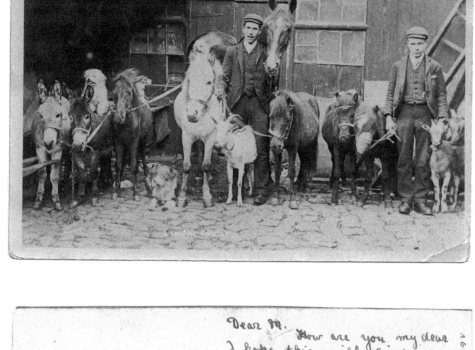

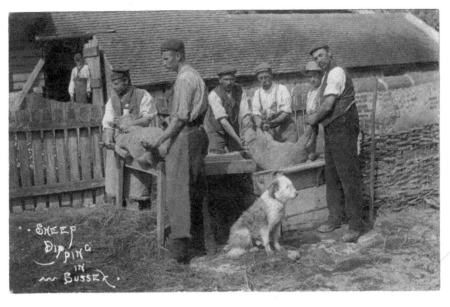

SHEEP
DIPPING
IN
SUSSEX.

POST CARD.

THE ADDRESS ONLY TO BE WRITTEN HERE.

FOR INLAND POSTAGE ONLY, THIS SPACE MAY NOW BE USED FOR COMMUNICATION.

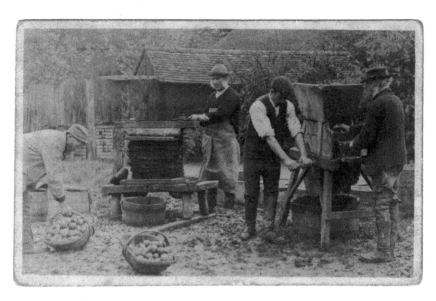

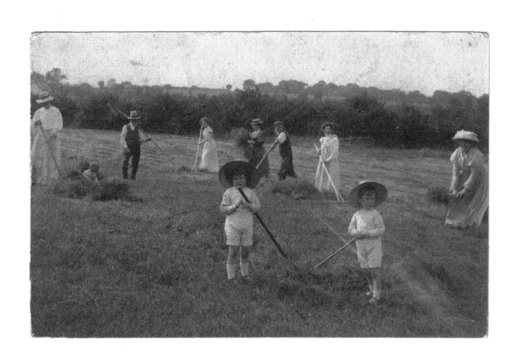

I have been looking in my box, for a card, which I have unable to find, however, so I am sending you, this pretty scene, of harvest-time. In examining ~~your~~ my box, I came across many of your earlier letters. One you signed Yours *ever*. I hope you keep true dear heart because I love you better than ever

Sweetest love Walter XX

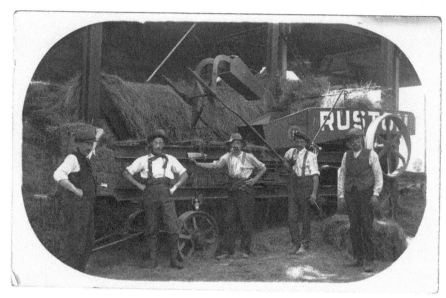

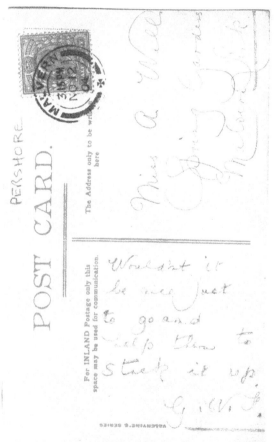

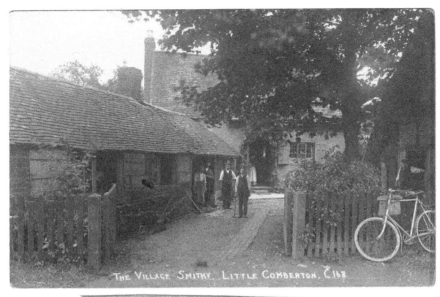

THE VILLAGE SMITHY, LITTLE COMBERTON. C168

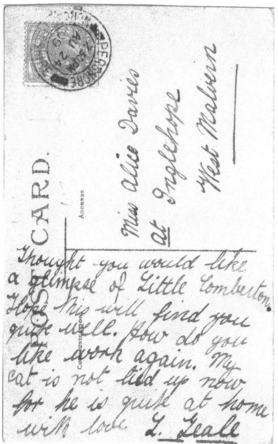

POST CARD.

ADDRESS

Miss Alice Davies
At Inglehope
West Malvern

Thought you would like
a glimpse of Little Comberton.
I hope this will find you
quite well. How do you
like work again. My
cat is not tied up now
for he is quite at home
with love L. Geale

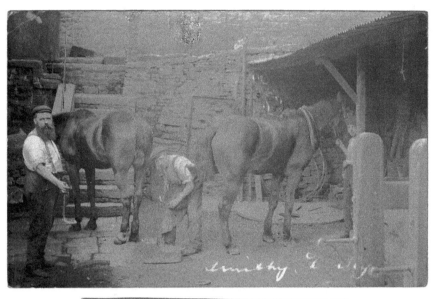

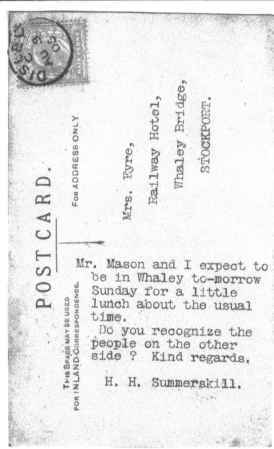

POST CARD.

FOR ADDRESS ONLY

THIS SPACE MAY BE USED
FOR INLAND CORRESPONDENCE.

Mrs. Eyre,
　　Railway Hotel,
　　　Whaley Bridge,
　　　　STOCKPORT.

Mr. Mason and I expect to
be in Whaley to-morrow
Sunday for a little
lunch about the usual
time.
Do you recognize the
people on the other
side ? Kind regards.

H. H. Summerskill.

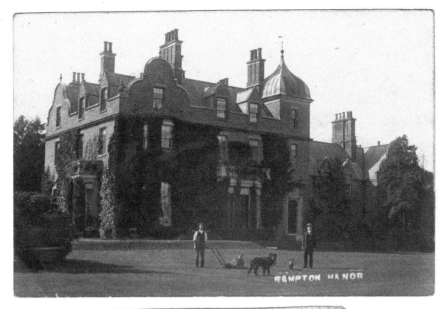

RAMPTON MANOR

Dear Madge.
— Did the weather
allow you to see "J." at the "C"
last night? —
Am thinking of taking a
Situation down here as haymaker
4/= day & 1/2 gall. ale
hour from D.

Miss Shorwell
% Gardeners
Raleigh St
Nottingham

POST CARD
ADRESS HERE

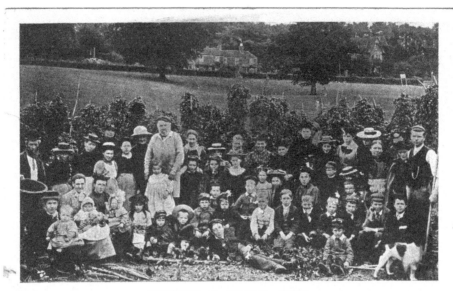

HOP-PICKERS AT UCKFIELD, SUSSEX.

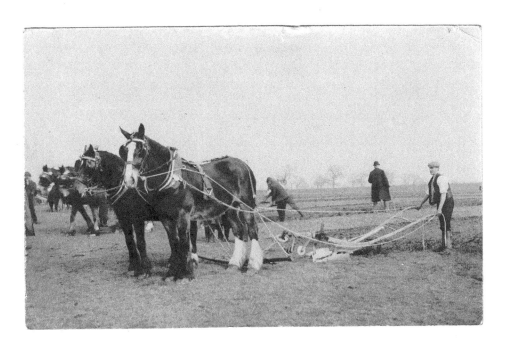

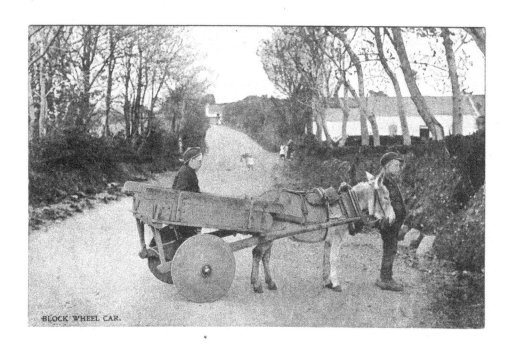

BLOCK WHEEL CAR.

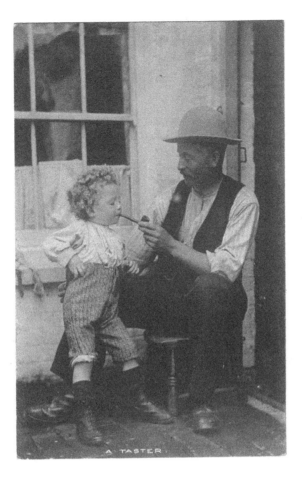

A TASTER.

ROYALTY

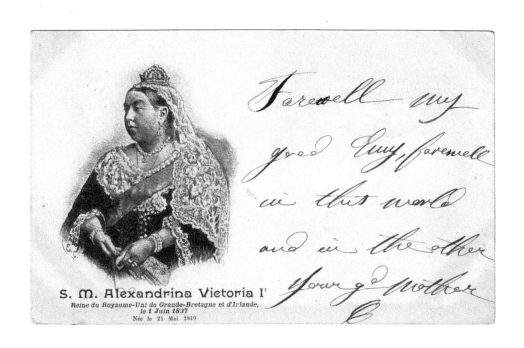

S. M. Alexandrina Victoria I^r
Reine du Royaume-Uni de Grande-Bretagne et d'Irlande,
le 1 Juin 1837
Née le 24 Mai 1819

Farewell my good Lucy, farewell in this world and in the other Yours & Mother

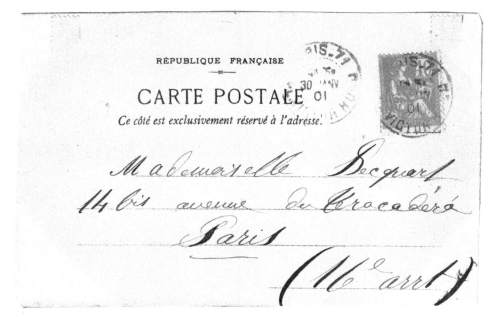

RÉPUBLIQUE FRANÇAISE

CARTE POSTALE

Ce côté est exclusivement réservé à l'adresse.

Mademoiselle Becquart
14 bis avenue du Trocadéro
Paris
(16e arr^t)

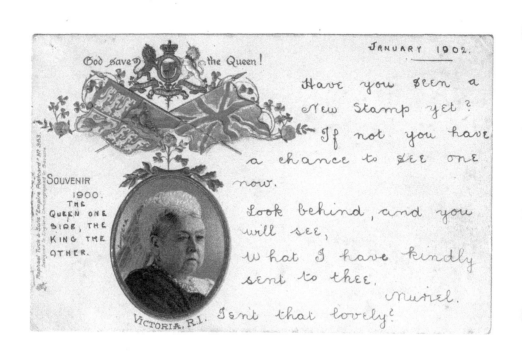

God save the Queen!

JANUARY 1902.

Souvenir 1900. The Queen one side, the King the other.

VICTORIA, R.I.

Have you seen a
new stamp yet?
If not you have
a chance to see one
now.

Look behind, and you
will see,
What I have kindly
sent to thee.
Muriel.
Isn't that lovely?

POST CARD

THE ADDRESS TO BE WRITTEN ON THIS SIDE.

HALF PENNY

Miss . E . M . Reely.
Sotwell Hill.
Wallingford.
Berks.

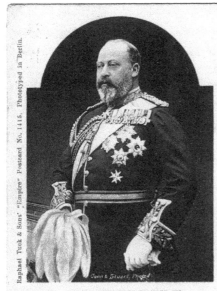

"TO MY PEOPLE BEYOND THE SEAS.

"With such loyal support I will, with God's blessing, solemnly work for the promotion of the common welfare and security of the great Empire over which I have now been called to reign.
"EDWARD R.I.

"WINDSOR CASTLE, Feb. 4, 1901."

August 18th 1902.

Another card for your col-lection, he the King, is really crowned at last. We saw him splendidly at Whitehall on his return from the Abbey and the Queen bowed our way and bowed — also the Prince & Princess of Wales. Love from all to all —

HIS MAJESTY KING EDWARD VII.

POST CARD.
THE ADDRESS TO BE WRITTEN ON THIS SIDE.

Mrs. E. F. Pearson.
Smyrna Cottage.
Windsor Avenue.
Osborne Road.
Blackpool. South Shore.

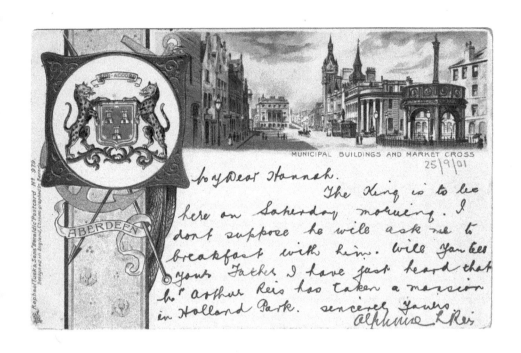

My Dear Hannah.

The King is to be here on Saturday morning. I dont suppose he will ask me to breakfast with him. Will you tell your Father I have just heard that Mr Arthur Reis has taken a mansion in Holland Park. sincerely Yours

Alphonse L Reis

25/9/01

MUNICIPAL BUILDINGS AND MARKET CROSS

POST CARD.

THE ADDRESS TO BE WRITTEN ON THIS SIDE

Miss. Bamberger

3 Lancaster Road

Belsize Park

London n.w.

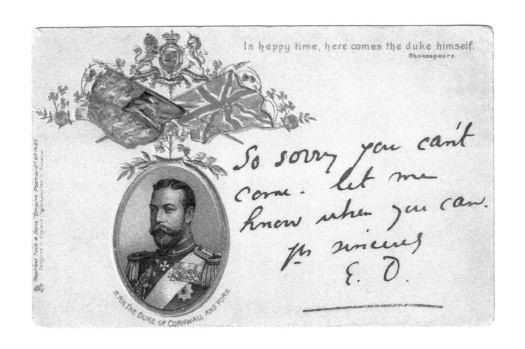

In happy time, here comes the duke himself.
Shakespeare

So sorry you can't come. Let me know when you can.
Yr sincerely
E. D.

H.R.H.THE DUKE OF CORNWALL AND YORK

Raphael Tuck & Sons "Empire Postcard" No. 1433

POST CARD

THE ADDRESS TO BE WRITTEN ON THIS SIDE

Miss Bessie Chatten
7 Lansdowne Place East

Bath

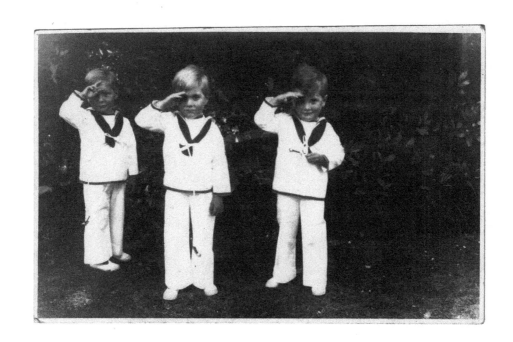

POST CARD

CARTE POSTALE

Communication—Correspondance Address—Adresse

STAMP
HERE

Jeremy, Robin & Anthony saluting the
King & Queen at Osborne, when
King talked to them last summer

Blenheim Palace and Italian Gardens.

POST CARD.

THE ADDRESS ONLY TO BE
WRITTEN HERE.

THIS SPACE CAN BE USED FOR INLAND
CORRESPONDENCE ONLY.

"Country" Series. No. 1444. Copyright.

Master Bernard Crabbe
10 Manor Villas
Finchley (C. Saw)
London N.

These gardens were in
purple & white flowers,
half mourning for King Edward.
The walls of the park are
13 miles round. Weather
not very promising but no
rain yet.
Monday. 9. am
8. VIII . 1910

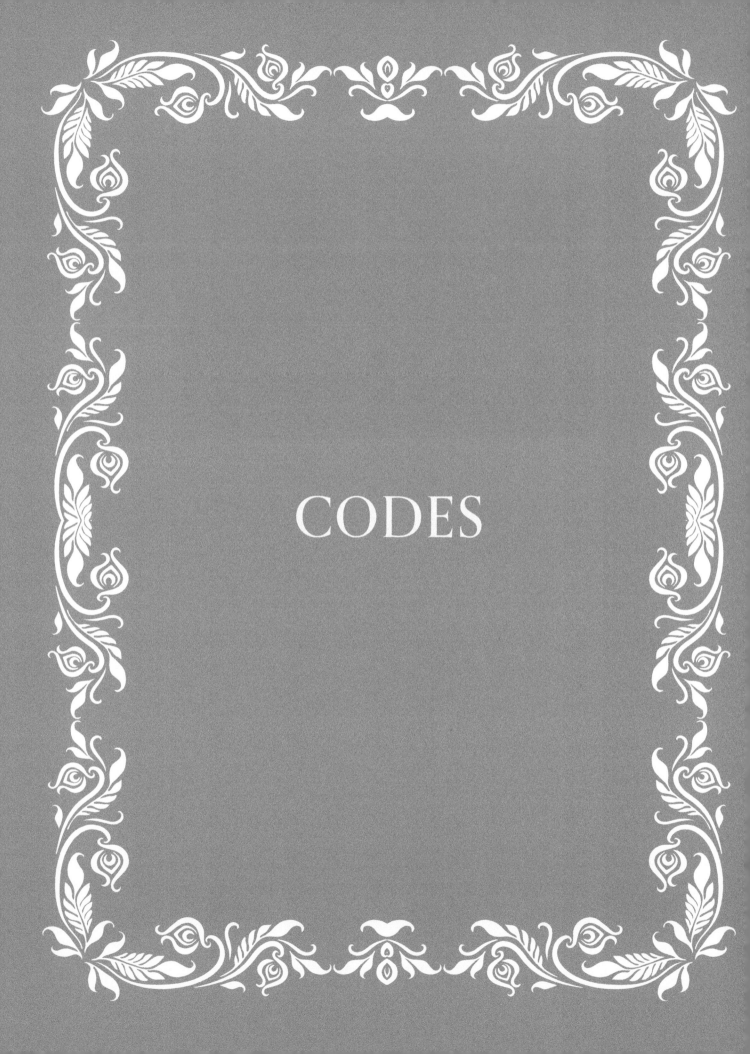

CODES

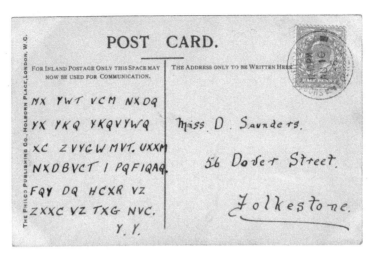

POST CARD.

FOR INLAND POSTAGE ONLY THIS SPACE MAY
NOW BE USED FOR COMMUNICATION.

THE ADDRESS ONLY TO BE WRITTEN HERE

NX YWT VCM NXDQ

YX YKQ YKQVYWQ

XC ZVYGW MVT. UXXM

NXDBVCT I PQFIQAQ

FQY DQ HCXR VZ

ZXXC VZ TXG NVC.

Y. Y.

Miss D. Saunders.

56 Dover Street.

Folkestone.

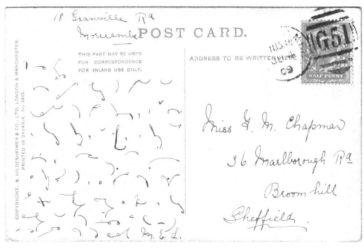

18 Granville Rd
Morecambe POST CARD.

THIS PART MAY BE USED
FOR CORRESPONDENCE
FOR INLAND USE ONLY.

ADDRESS TO BE WRITTEN HERE

HALF PENNY

Miss F. M. Chapman
36 Marlborough Rd
Broomhill
Sheffield.

POST CARD

THIS SPACE, AS WELL AS THE BACK, MAY NOW
BE USED FOR COMMUNICATION,
BUT FOR INLAND ONLY.

THE ADDRESS ONLY
TO BE WRITTEN HERE.

Miss A. Trevarthen
+ West End
Witney
Oxon

POST CARD

Printed in Britain

Rotary Photo, London. E.C.

This is a HAND-COLORED REAL PHOTOGRAPH
of a BRITISH Beauty

Hope you like this!
Kenneth

G. Harold Mason Esq
Ashby House
Water Orton
Birmingham

POST CARD
(FOR INLAND USE ONLY.)

This Space as well as the back may now be
used for communication.
(Post Office Regulation.)

THE ADDRESS TO BE
WRITTEN HERE.

Raed Emadam.
I llahs eb ta
raoy esuoh
yb 28hcolc ot
yad. Epoh uoy era
lla thgir. Sruoy,

Semaj A. Llahs

Miss M. Brumby
111 Wallace Rd
Sheffield. N.

SOCIAL
HISTORY

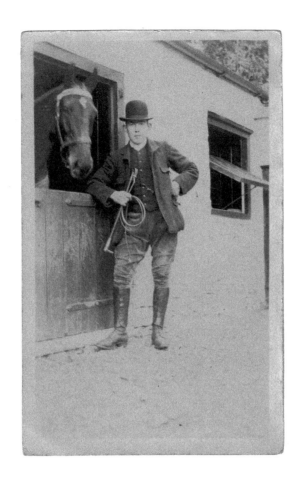

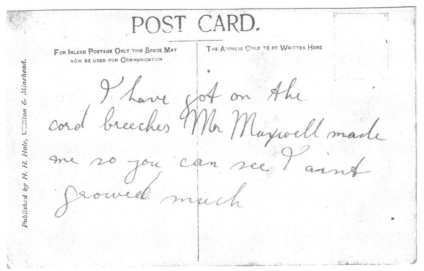

POST CARD.

For Inland Postage Only this Space May
NOW BE USED FOR COMMUNICATION

The Address Only to be Written Here

Published by H. H. Hole, Williton & Minehead.

I have got on the
cord breeches Mr Maxwell made
me so you can see I aint
growed much

117

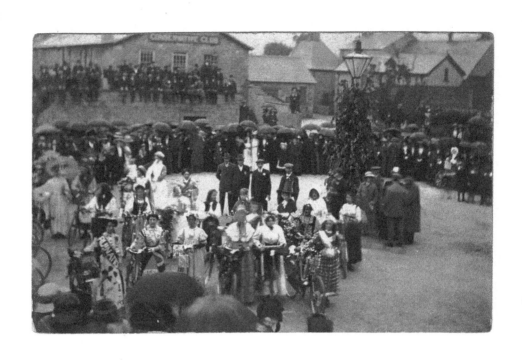

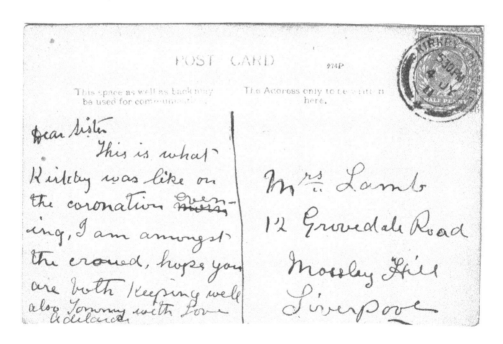

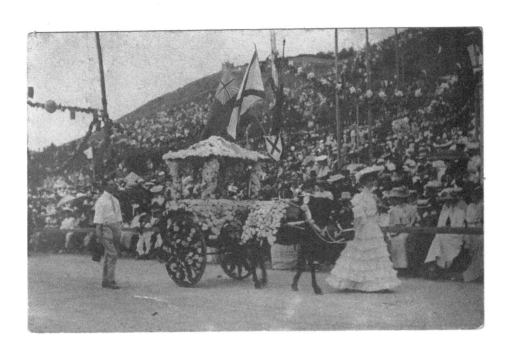

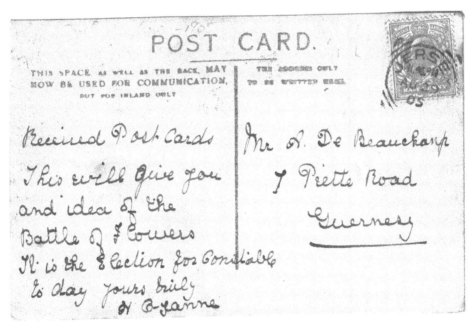

Received Post Cards
This will give you
and idea of the
Battle of Flowers
It is the Election for Constable
to day yours truly
H Ozanne

Mr A. De Beauchamp
7 Piette Road
Guernsey

POST CARD.

THIS SPACE, as well as the back, MAY
NOW BE USED FOR COMMUNICATION,
BUT FOR INLAND ONLY

THE ADDRESS ONLY
TO BE WRITTEN HERE.

119

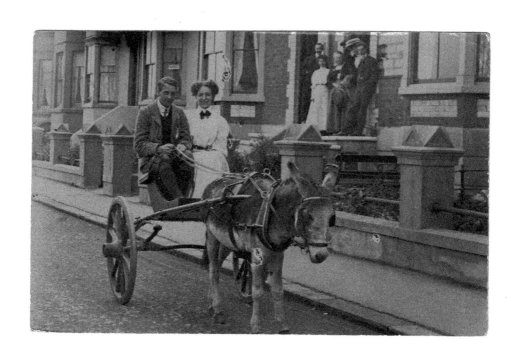

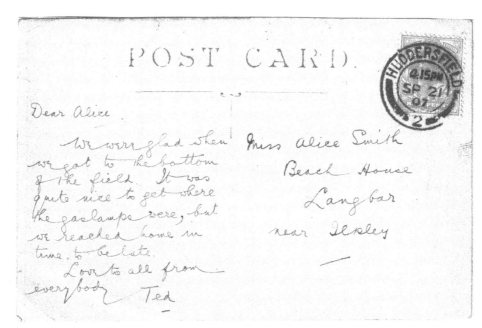

POST CARD.

Dear Alice.

We were glad when we got to the bottom of the field. It was quite nice to get where the gaslamps were, but we reached home in time to be late.

Love to all from everybody

Ted

Miss Alice Smith
Beach House
Langbar
near Ilkley

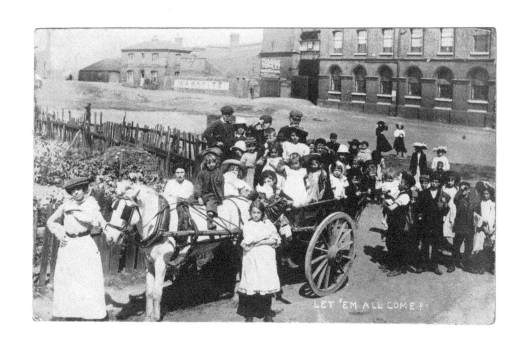

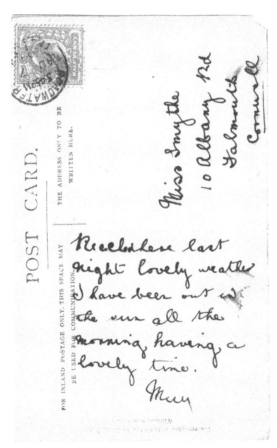

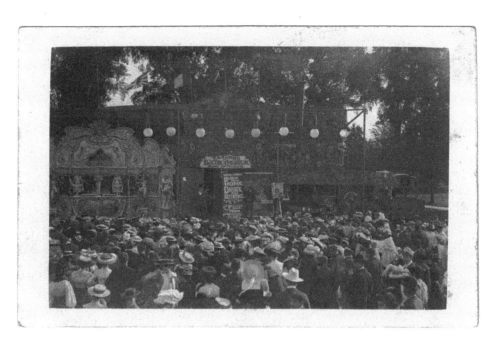

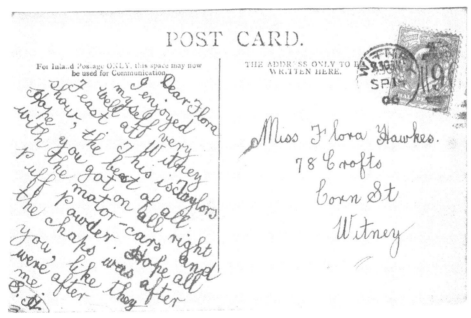

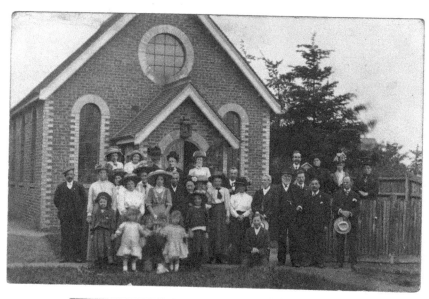

Dear Mrs Standbrook (Woking)
A party of us hope to
visit Mayford Green & hold an
open air Evangelistic Meeting on
Wednesday. tonight at 7:30.
Would you be so kind as to
lend us a harmonium. We will
take great care of it. I will
play it myself. Thanking you.
yours sincerely
R. Fifield

Correspondence Address only.

Post Card.

Mrs Standbrook,
Strict Bapt Chapel.
Mayford.
Woking.

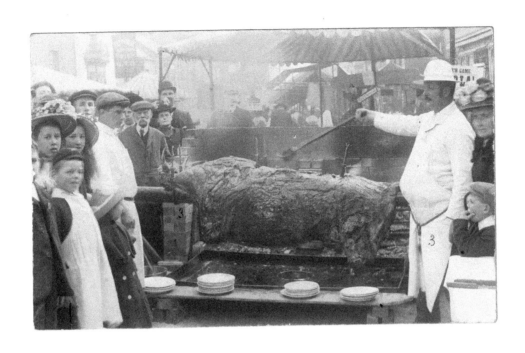

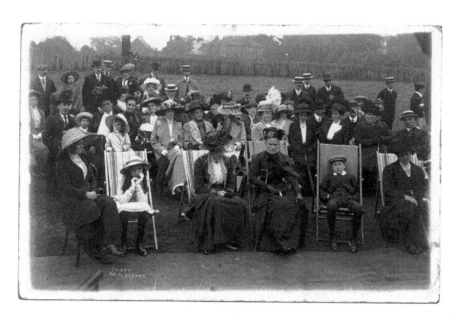

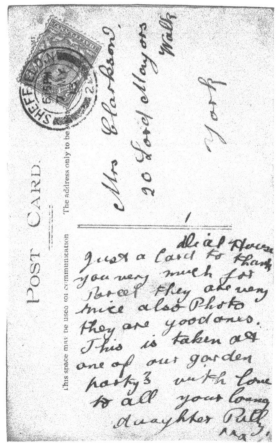

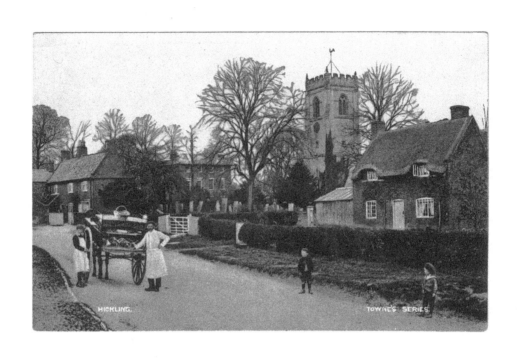

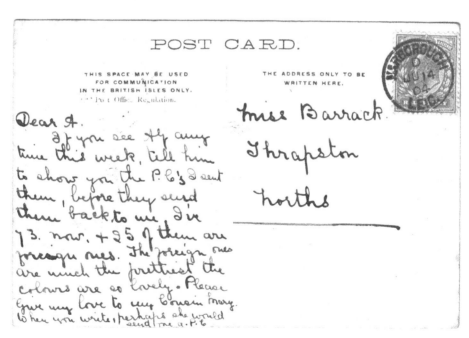

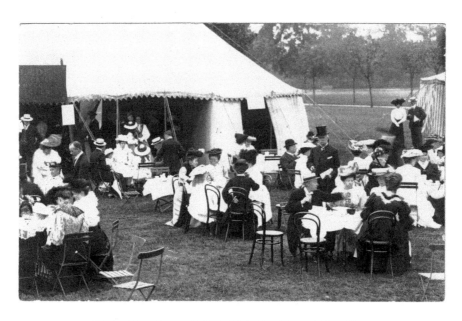

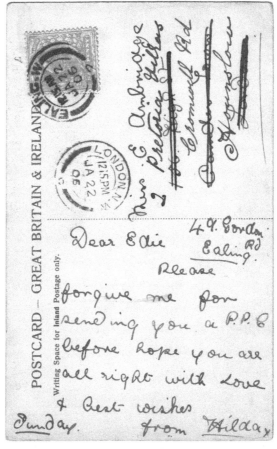

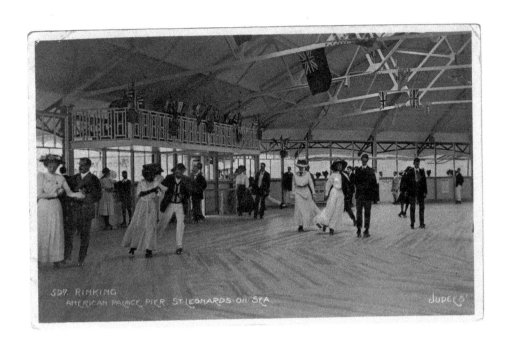

597. RINKING
AMERICAN PALACE PIER. ST LEONARDS ON SEA. JUDGES

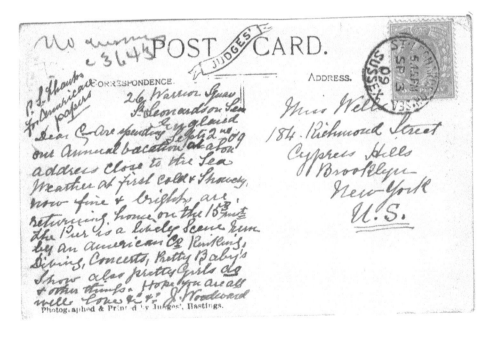

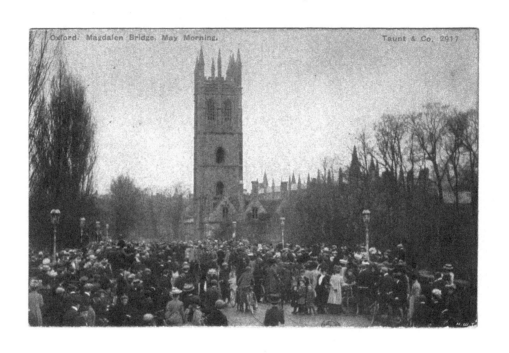

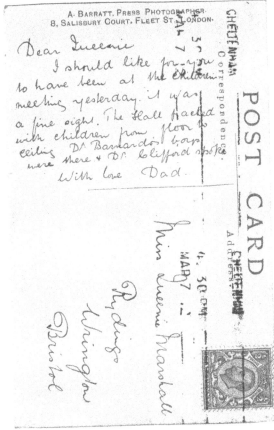

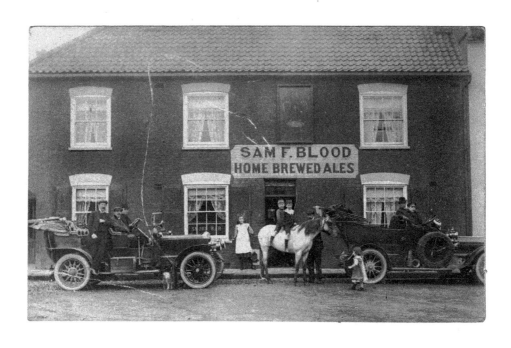

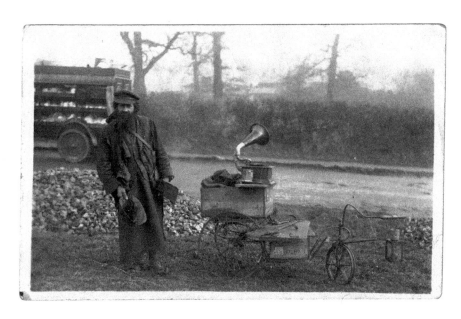

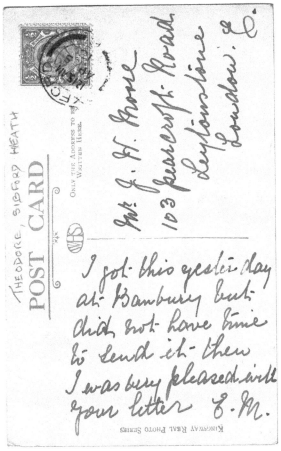

THEODORE, SIBFORD HEATH

POST CARD

ONLY THE ADDRESS TO BE
WRITTEN HERE.

Mr. J. H. Stone
103 Fiarcroft Road
Leytonstone
London. E.

I got this yesterday
at Banbury but
did not have time
to send it then
I was very pleased with
your letter E.M.

Kingsway Real Photo Series

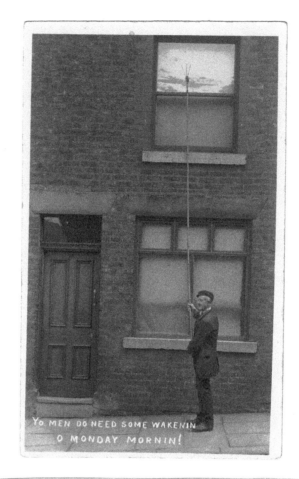

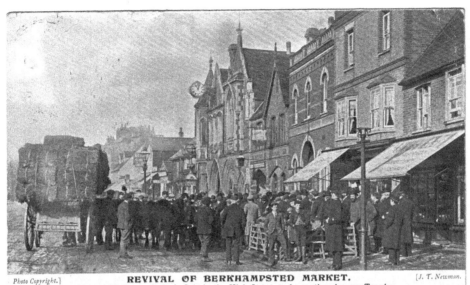

Photo Copyright.]

REVIVAL OF BERKHAMPSTED MARKET.

[J. T. Newman.

Messrs. W. Brown & Co.'s Sale in the High Street, to be continued every Tuesday.

The market dates from the year 1156, when a charter was granted by Henry II.

POST CARD.

THIS SPACE MAY BE USED FOR PRINTED OR WRITTEN MATTER FOR INLAND USE ONLY.

THE ADDRESS ONLY TO BE WRITTEN HERE.

TRING.
26/3/06.

Dr. Sir :—
 We shall have about
50 Sheep, 4 or 5 Beasts
and a few pigs at Berkham-
-sted market tomorrow.
Shall be glad to see you

over if convenient,

 Yours faithfully,
 F. I. Brown

Mr. Rose,

 Butcher,

 Chesham.

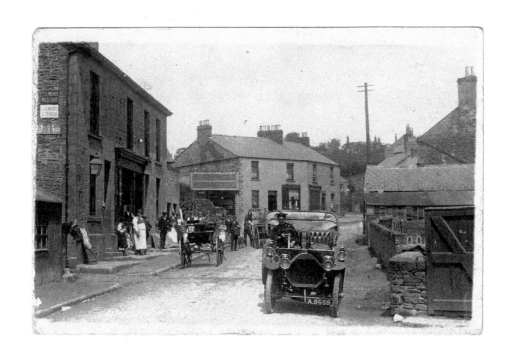

POST CARD

For Inland Communication only this Space may be used

For Address only.

Affix
Stamp
Here

DRYBROOK

This is the Shop
were Hiram .
do work. that
is him in the doorway.
and the boss. at the
door, that stout gentleman .

Mr R. Davis
18 Herbert St
Gloucester

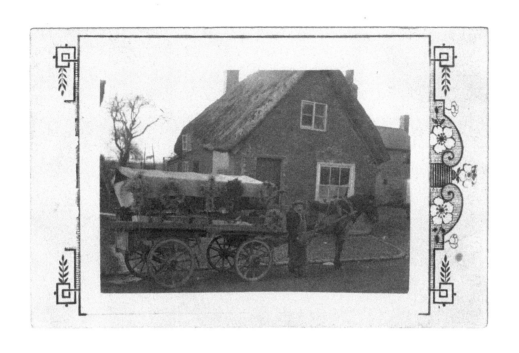

POST CARD.

ROTARY PHOTOGRAPHIC SERIES

For Inland Postage only, this Space as well as the back may now be used for Communication Post Office Regulation).

THE ADDRESS ONLY TO WRITTEN HERE.

Dear Maud
 I will meet you
to night at 7-30

 Len

Miss. M. Watson
 97 Sebert Rd.

 Forest Gate

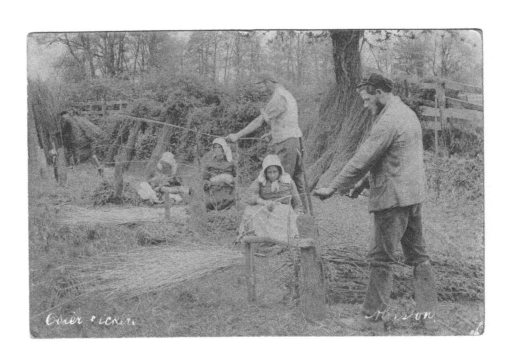

Osier Pickers. Alveston.

POST CARD

FOR CORRESPONDENCE.

FOR ADDRESS ONLY.

HALF PENNY

Miss Freda Ellis
17. College Street

S— on A—

138

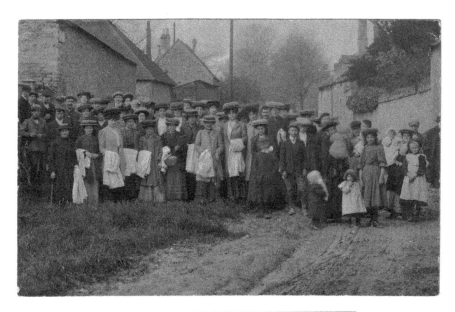

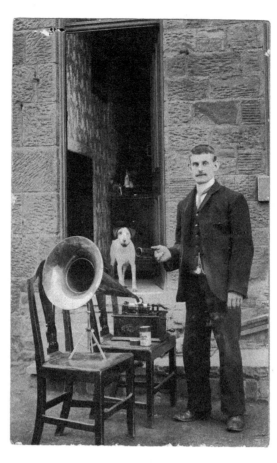

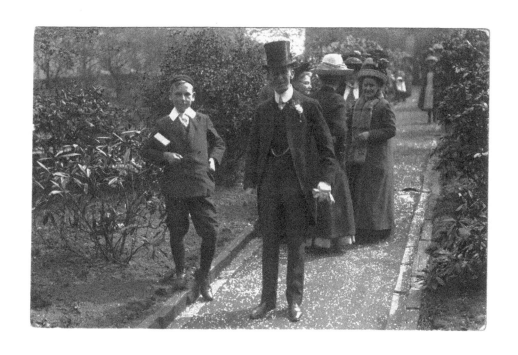

141

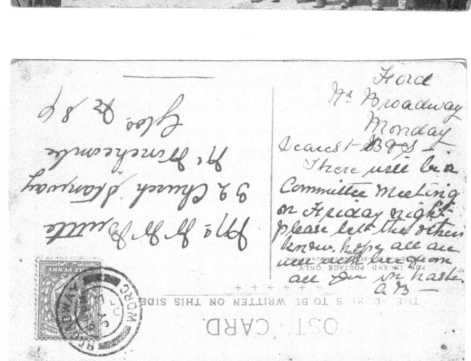

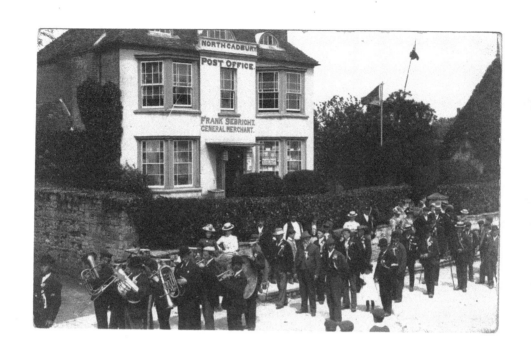

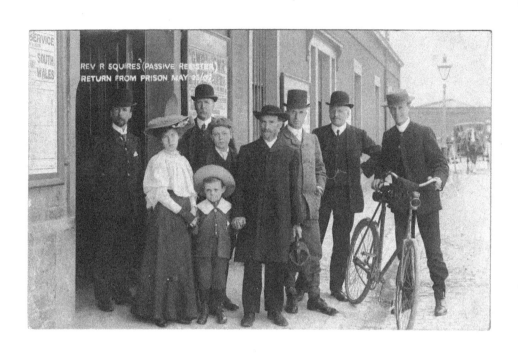

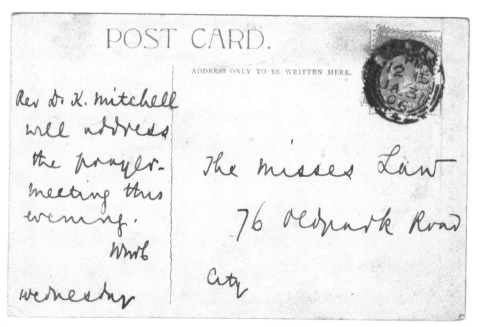

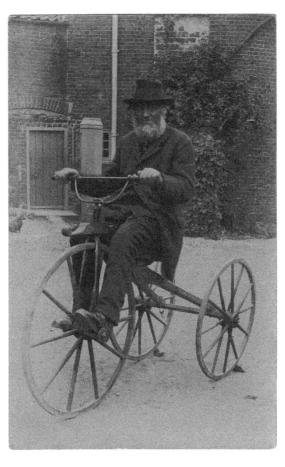

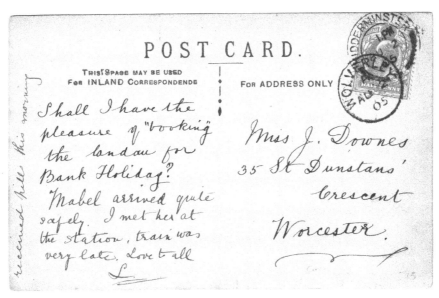

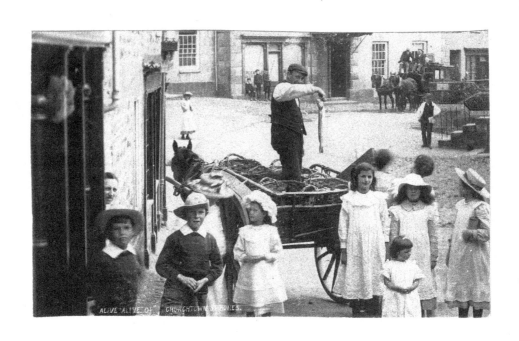

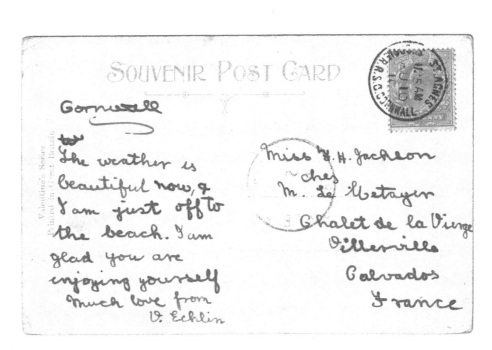

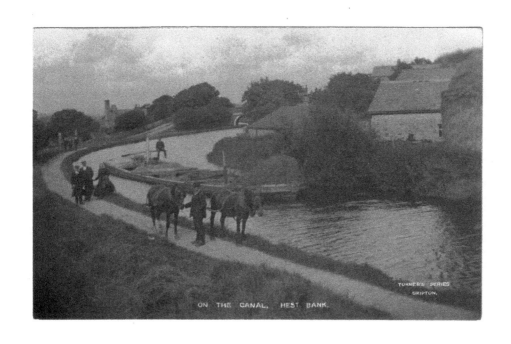

ON THE CANAL, HEST BANK.

Sunday As kingdown ...

My Dear Harry I am *late* as usual but I made a mistake in the date I want to wish you a very happy birthday (that is gone) I hope you like your new sit & that you will get on hope you are well how do you like being in london lots of love

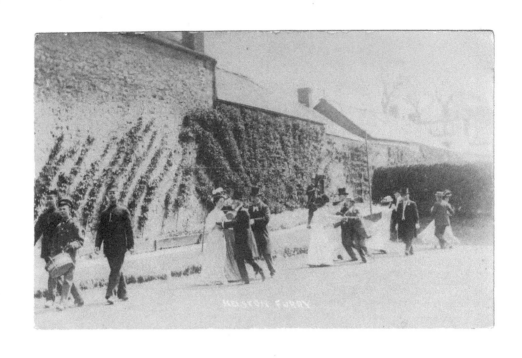

HELSTON FURRY

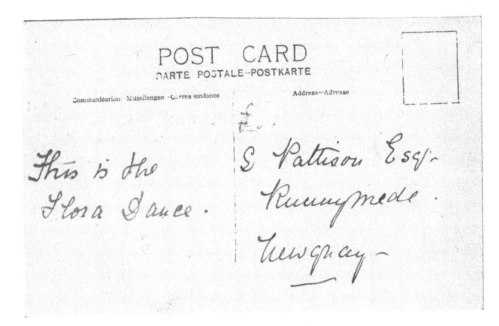

POST CARD
CARTE POSTALE-POSTKARTE

Communication Mitteilungen Correspondance Address—Adresse

This is the
Flora Dance.

S Pattison Esq.
Runnymede.
Newquay

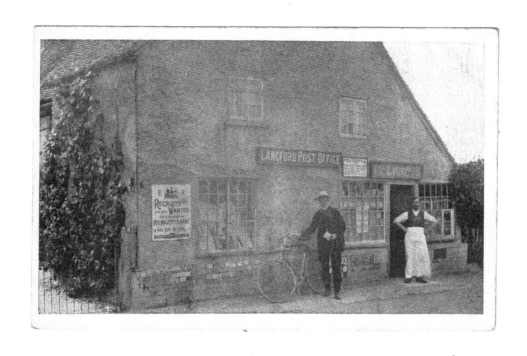

Tell Clara she will be able
to see her way about when
she comes next time because
we have got the lights
I expect Clara is getting quite
a young Woman now
x x x x x for Clara

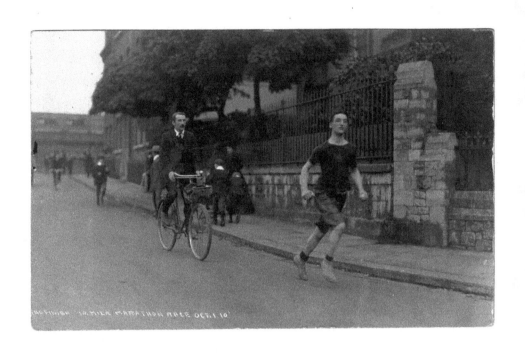

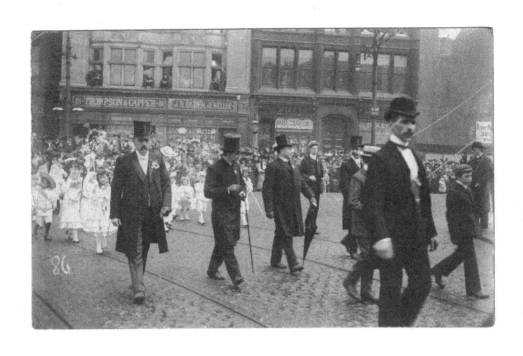

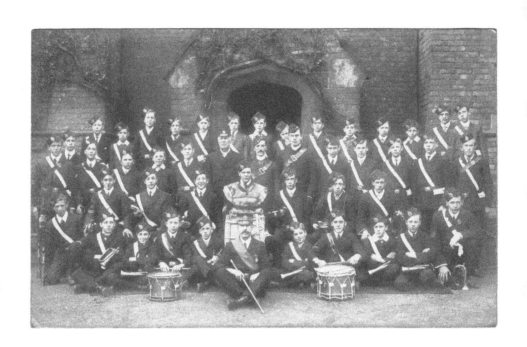

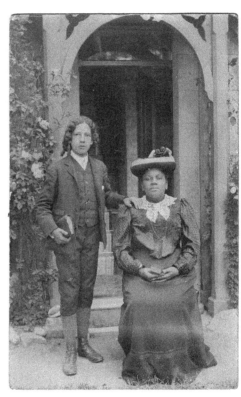

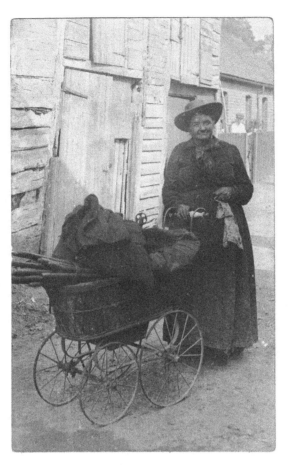

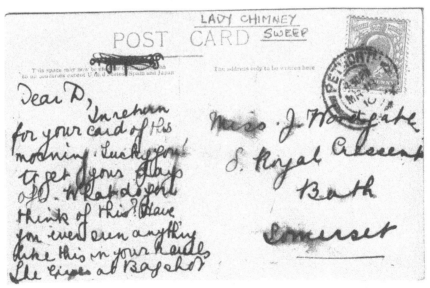

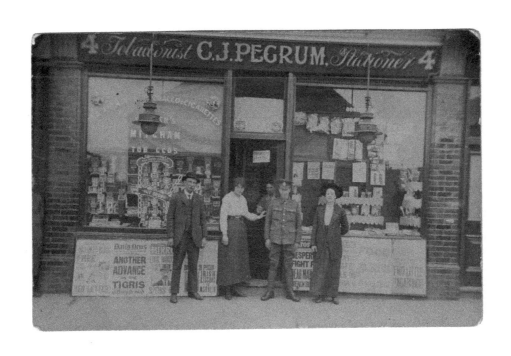

MITCHAM

POST CARD.

For INLAND Postage only this space may
be used for communication.

Dearest B.

Hope you & all home
are well thought I
would send this as
it is two weeks since
I wrote & thought something
must be wrong. Write soon
Best love from Polly.

The ADDRESS only to be written here.

Miss B. Hale
Bramfield Place Farm
Hertford.

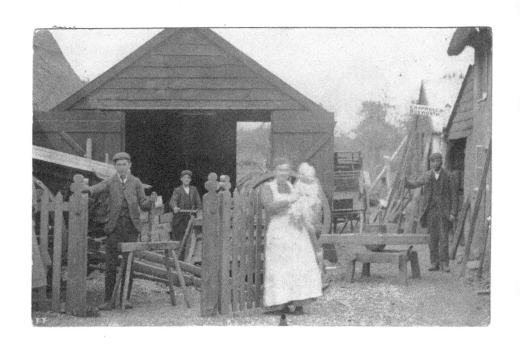

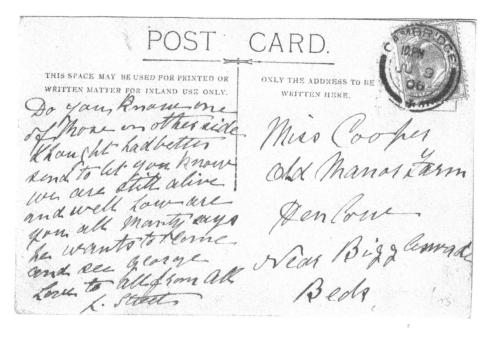

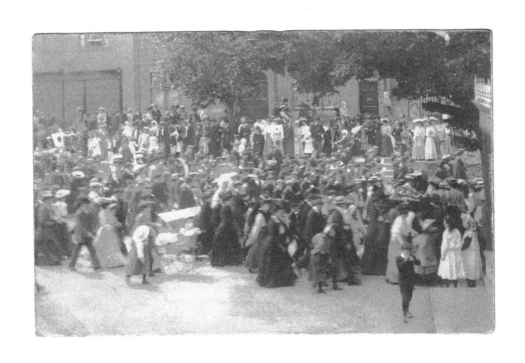

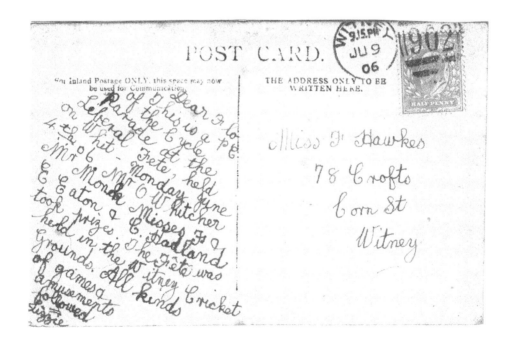

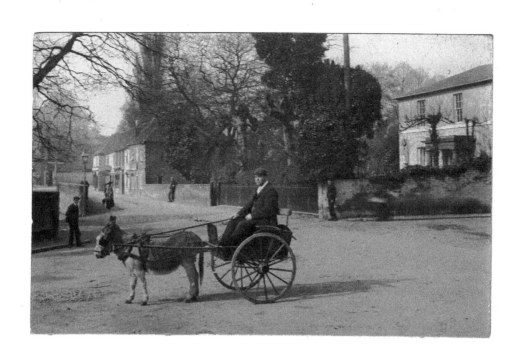

POST CARD

(For Inland use only.)

This Space as well as the back may now be
used for communication.
(Post Office Regulation)

THE ADDRESS TO B
WRITTEN HERE.

Dear Mur,
 Have you
seen this?
Pity you are not
there to make a
third. M.S.

Mⁿˢ Hiam
"Melrose"
Yatton
Somerset

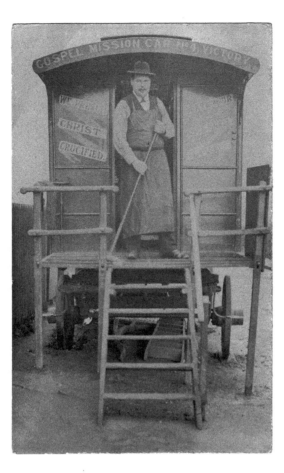

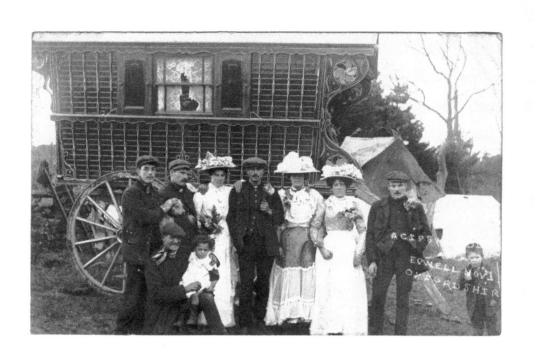

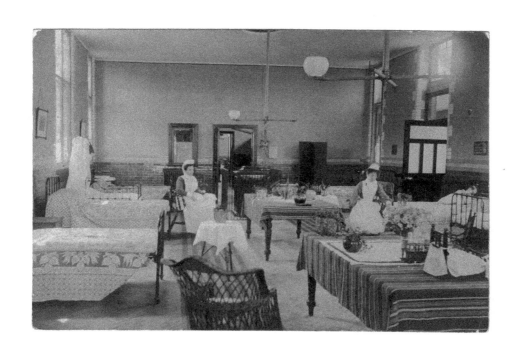

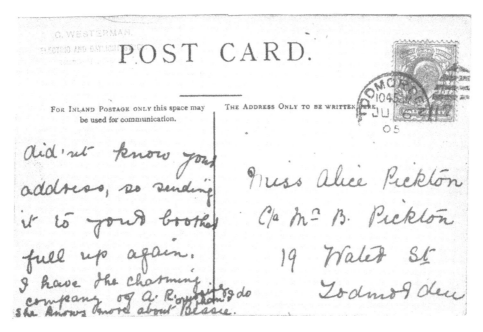

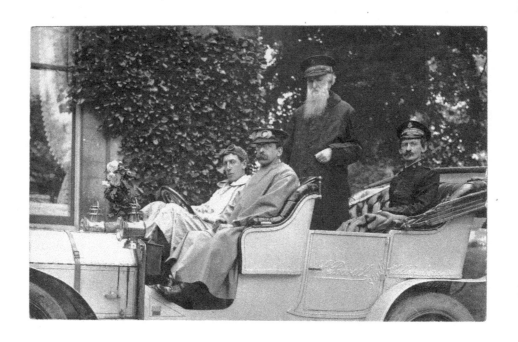

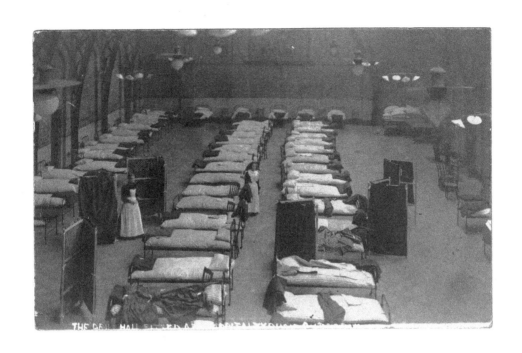

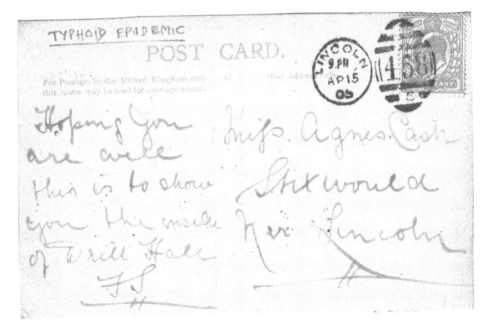

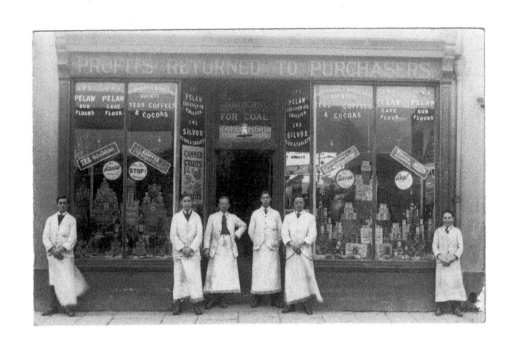

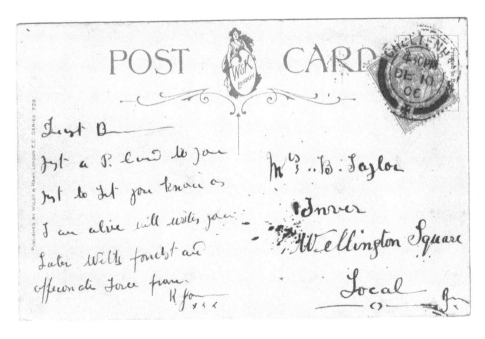

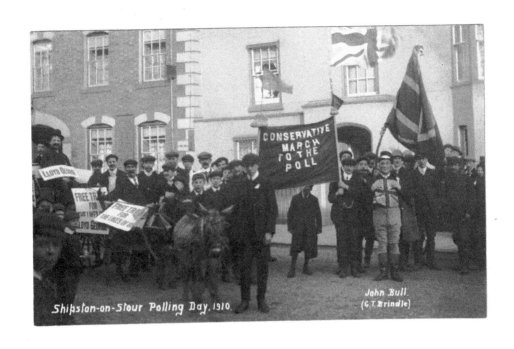

Shipston-on-Stour Polling Day, 1910.

John Bull.
(G.T. Brindle)

POST CARD

THE
"MERCIA"
SERIES.

FOR THIS SPACE AND POSTAGE THIS SPACE, AS WELL AS THE BACK, MAY NOW BE USED FOR COMMUNICATION.
For FOREIGN POSTAGE THE BACK ONLY.
(Post Office Regulation.)

THE ADDRESS ONLY TO BE
WRITTEN HERE.

Just a line
hoping you are
enjoying your holiday
with love from
Gladys

Miss Rutland,
5 Fairfield Avenue
Leckhampton
Cheltenham

HALF PENNY

1207

96930

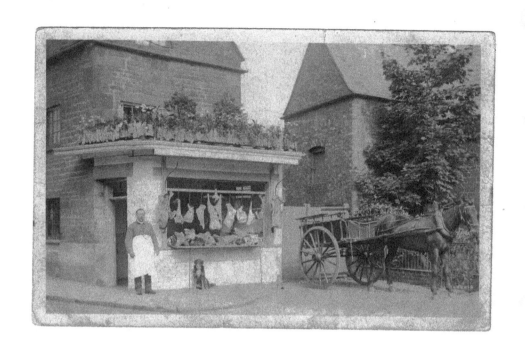

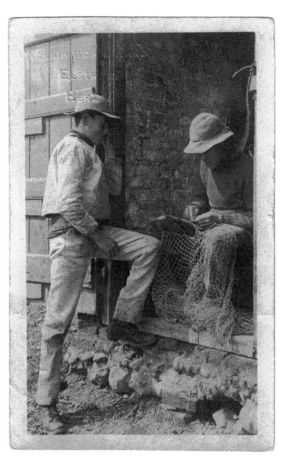

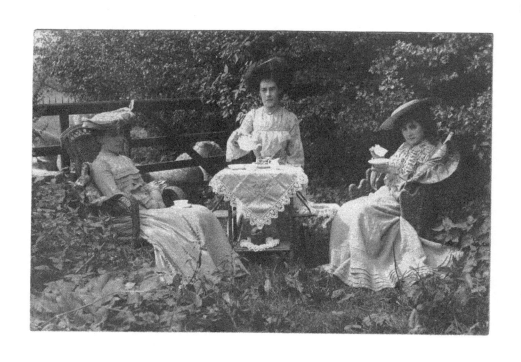

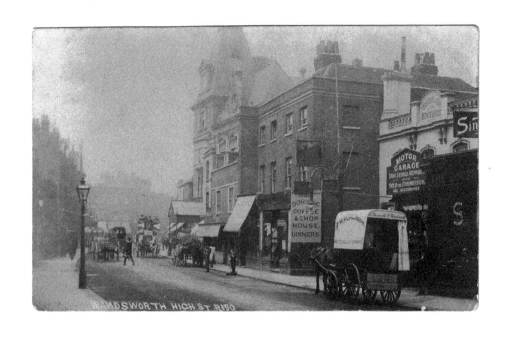

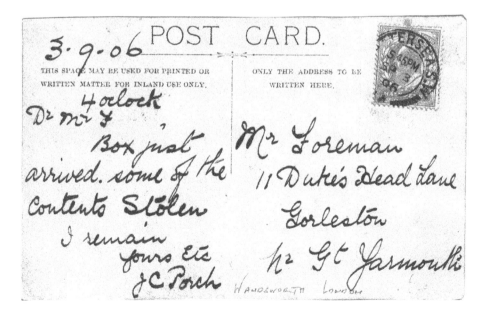

Dear Dick. West Hill

Hope you are improving. I am just going across to 'Bewick' to ask Daisy and Bertie for the evening. Mr Dunn was a little better yesterday. Hope you will like the post card. We shall try to get in to see you on Thursday before I go back.

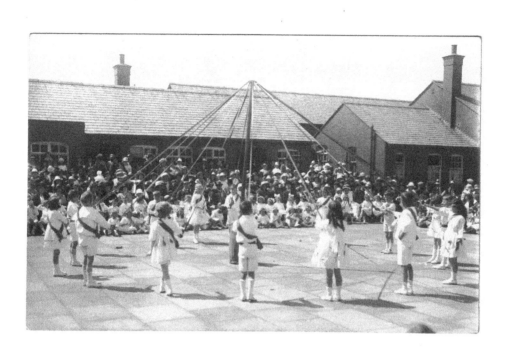

POST CARD

THIS SPACE MAY BE USED FOR CORRESPONDENCE,
EXCEPT FOR POSTING ABROAD.

THE ADDRESS ONLY
TO BE WRITTEN HERE

4/2/06

With a kiss from
Dolly to dear
Mamma

Miss Bond
Richmond
65A Promenade
Southport

INTERESTING/
UNUSUAL

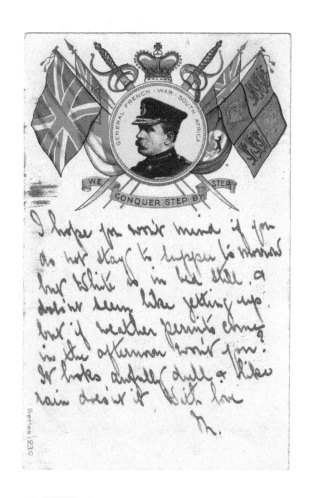

I hope you won't mind if you
do not stay to supper to-morrow
but White is in bed still, I
doesn't seem like getting up
but if weather permits come
in the afternoon won't you.
It looks awfully dull & like
rain doesn't it With love
M.

POST CARD.

Mr. H. P. Scott
Bisham Lodge
Thames Ditton

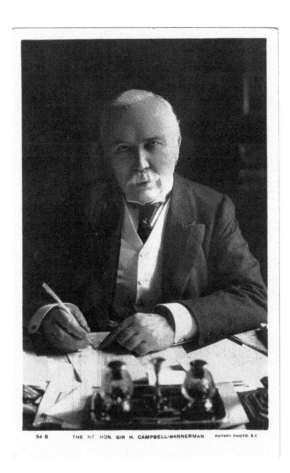

54 B THE RT HON. SIR H. CAMPBELL-BANNERMAN ROTARY PHOTO. E.C

Three cheers for the Red White and Blue.

Your "Evergreen" instructions
shall have my prompt
& serious attention
C.F.G
Lyons
22/2/03

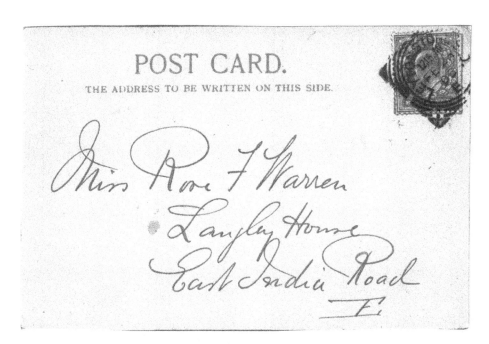

Miss Rose F Warren
Langley House
East India Road
E.

Barnes March 22, 1902.

The Oxford & Cambridge Boat Race took place between Putney & Mortlake to-day. The result was a win for the Light blues by 8 lengths. Of the previous races Oxford has won 33 and Cambridge 24. For the first time America was represented, the two Milburns hailing from U.S.A., having places in the Oxford boat.

THE CAMBRIDGE CREW —FETCHING THE OARS

OXFORD.	Names and Weights.	CAMBRIDGE.	
	st. lb.		st. lb.
G. C. Drinkwater, Wadham (bow)	11 7	a W. H. Chapman, Third Trinity (bow)	11 4
2. D. Milburn, Lincoln	12 4½	T. Drysdale, Jesus	12 4½
3. a J. Younger, New	12 13	P. H. Thomas, Third Trinity	12 4½
4. a H. J. Hale, Balliol	13 0	a C. W. H. Taylor, Third Trinity	12 9
5. J. G. Milburn, Lincoln	13 4½	F. J. Escombe, Trinity Hall	12 10
6. a A. de L. Long, New	13 2½	a H. B. Grylls, First Trinity	12 12
7. a H. W. Adams, University	12 1	J Edwards-Moss, Third Trinity	12 5¾
F. O. J. Huntley, University (stroke)	11 6½	a R. H. Nelson, Third Trinity (stroke)	11 7½
a G. C. Maclagan, Magdalen (cox.)	8 5	H. C. Washbrough, Trinity Hall (cox.)	8 6

a An Old Blue.

The Oxford men used the Brocas boat designed by Dr Ware of Eton in which they won so sensationally last year. The Cantabs relied on the old Sims' pattern.

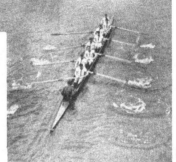

THE OXFORD CREW—AT WORK

POST CARD
THE ADDRESS ONLY TO BE WRITTEN ON THIS SIDE.

Miss Somerville
Springfield Court
Chelmsford
Essex

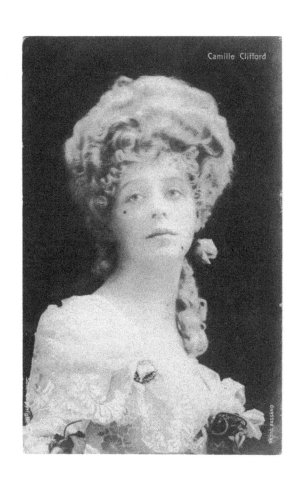

Camille Clifford

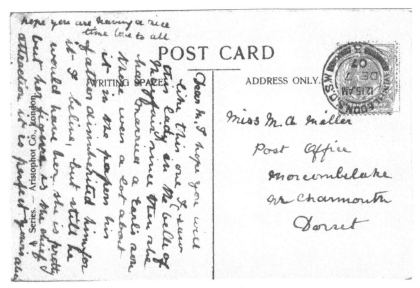

POST CARD

WRITING SPACE ADDRESS ONLY.

Miss M. A. Miller
Post Office
Morcombelake
nr Charmouth
Dorset

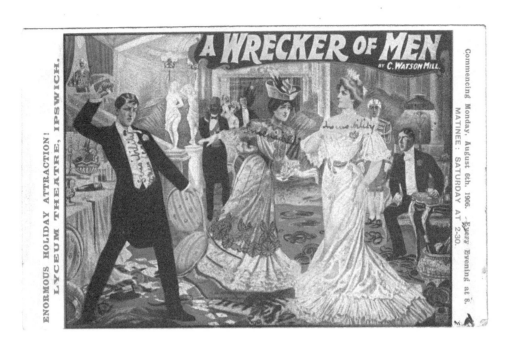

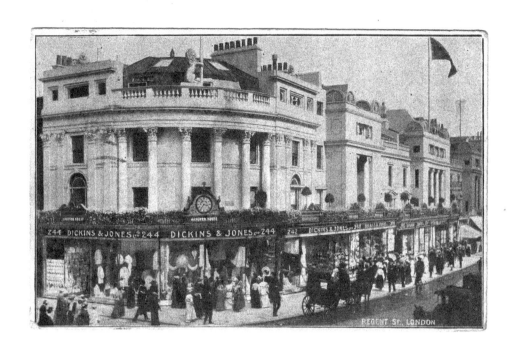

POST CARD.

DICKINS & JONES' SALE

SUMMER GOODS SUITABLE FOR
SEASHORE AND COUNTRY WEAR AT
STILL **FURTHER REDUCTIONS**
FOR TWO WEEKS COMMENCING . .
Monday Next, July 18th.

SPECIAL.

WHITE LINEN COSTUMES COMPLETE **45** -
WHITE LINEN SKIRTS - - - - - **21/-**
WHITE HAND-EMBROIDERED LINEN
 BLOUSES - - - - - - - - - **13 9**
WHITE HAND-EMBROIDERED LINEN
 BLOUSES, UN-MADE - - **5 11 & 6 11**
THE NEW INVERNESS WRAP - - **29 6**

(FOR ADDRESS ONLY)

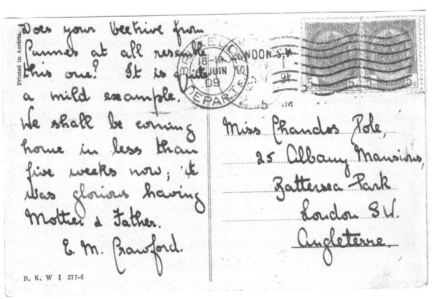

Does your beehive from Sumner at all resemble this one? It is only a mild example. We shall be coming home in less than five weeks now; it was glorious having Mother & Father.

E. M. Crawford.

B. K. W I 377-6

Miss Chandos Pole,
25 Albany Mansions,
Battersea Park,
London S.W.
Angleterre

THE COMET.

AND THE PLANET VENUS,

As seen at Oxford, Jan 29, 1910.

Copyright, Taunt & Co, 2838.

POST CARD

Seen by Winnie when up
having Tea with Mr & Mrs
Brockland at Littlemore
Sunday, Jan 30th 1910

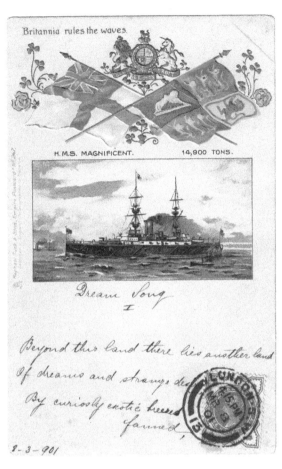

Britannia rules the waves.

H.M.S. MAGNIFICENT. 14,900 TONS.

Dream Song
I

Beyond this land there lies another land
Of dreams and strange des...
By curiosly exotic breeze
fanned,

8-3-901

POST CARD.
THE ADDRESS TO BE WRITTEN ON THIS SIDE.

INLAND ½ D
FOREIGN 1 D

Mrs Odone
152 Victoria Street
S. W.

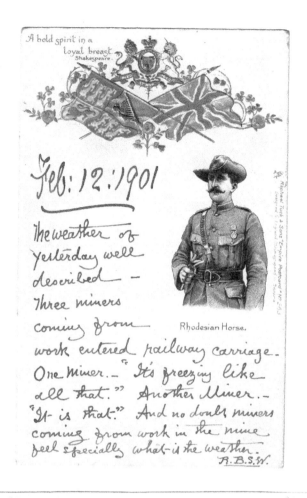

A bold spirit in a
loyal breast.
Shakespeare.

Feb: 12: 1901

The weather of
yesterday well
described —
Three miners
coming from
work entered railway carriage.
One miner.— "It's freezing like
all that." Another Miner.—
"It is that." And no doubt miners
coming from work in the mine
feel specially what is the weather.
A. B. S. W.

Rhodesian Horse.

POST CARD
THE ADDRESS TO BE WRITTEN ON THIS SIDE

The Reverend
J. B. S. Watson M.A.,
Chaplain's House
Maidstone

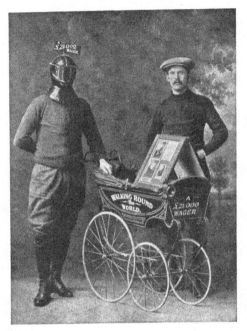

THE MAN WITH THE IRON MASK

WALKING ROUND THE WORLD

FOR A

£21,000 WAGER.

"Kent Messenger" Typ., Maidstone.

Dear Fluffy. Can you remember when this man came through in August, he looked just like this, how should you like to walk round the world, I wouldn't walk round for 50,000000 would you specially with a mask on How do you being at the Steam Laundry. With love & kisses from Poc Dinah.

£1,000 Reward—Lost.

Devon's Football Reputation at Redruth,
FEBRUARY 13th, 1908.

The unequalled Cornish Footballers are strongly suspected of having taken same.

AND SO SAY ALL OF US.

Could we but read our future ;	Had they known the Cornish sentence,
Could we but see our fate ;	**21** Points to a lucky **3,**
Devon would ne'er meet Cornwall,	Had they played a little longer ;
On that unlucky date.	What would the verdict be ?

Published by Bert Tucker & Co., Redruth.

POST CARD

FOR INLAND USE ONLY, PRINTED OR WRITTEN MATTER.

ONLY THE ADDRESS TO BE WRITTEN HERE.

Poor John is dead

Mrs M Rogers
℅ Dr N. Hitchens
Alma Place
Redruth

This in' one of the most charming Walks in' Cheltenham, JB.

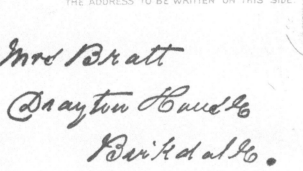

Mrs Bratt
Drayton Hurdle
Birkdale.

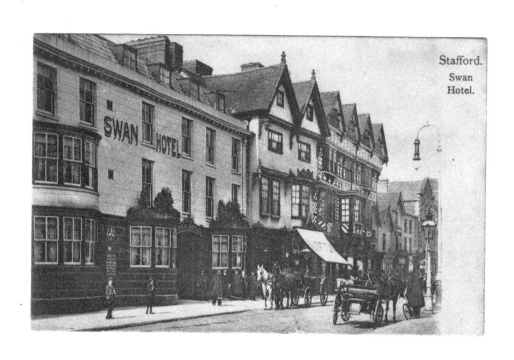

Stafford.
Swan
Hotel.

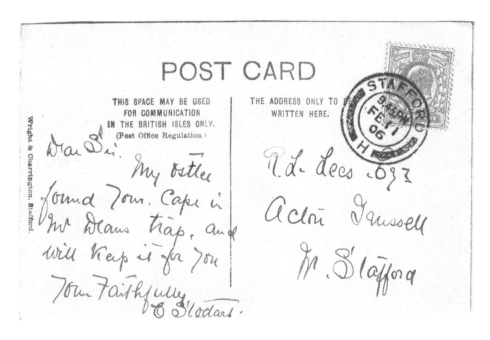

POST CARD

THIS SPACE MAY BE USED
FOR COMMUNICATION
IN THE BRITISH ISLES ONLY.
(Post Office Regulation.)

THE ADDRESS ONLY TO BE
WRITTEN HERE.

Wright & Charrington, Stafford.

Dear Sir.
My ostler
found Jom. Cape in
Mr Deans trap, and
will keep it for you
Your Faithfully
C Stodart.

R.L. Lees 693
Acton Trussell
Nr Stafford

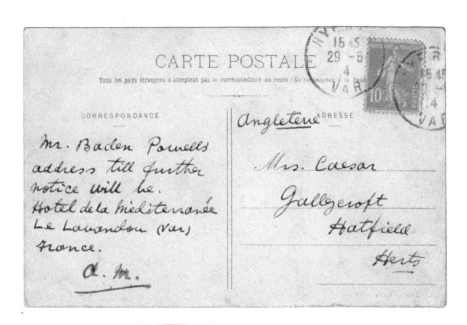

CARTE POSTALE

Tous les pays étrangers n'acceptent pas la correspondance au recto (Se renseigner à la Poste

CORRESPONDANCE

Mr. Baden Powells
address till further
notice will be.
Hotel de la Méditeranée
Le Lavandou (Var)
France.

a. M.

ADRESSE

Angleterre

Mrs. Caesar

Gallyeroft

Hatfield

Herts

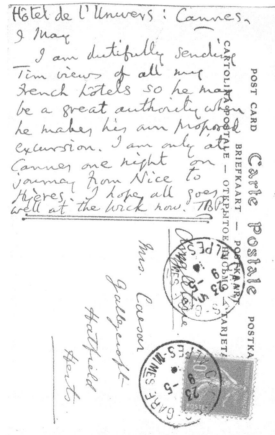

Hôtel de l'Univers: Cannes.
9 May
 I am dutifully sending
Tim views of all my
French hotels so he may
be a great authority when
he makes his own proposed
excursion. I am only at
Cannes one night on
journey from Nice to
Hières: I hope all goes
well at the work now. TB

Mrs. Caesar
Gallycroft
Hatfield
Herts

DARTMOUTH

POST CARD.

THE "CECILY" SERIES.

Write Here for Inland Postage only.

The Address only to be Written Here.

The building I have marked is the new Ryl Naval College, which is to be opened in June.

31 3 05

Miss Mulling
40 Richmond Rd
Ilford

190

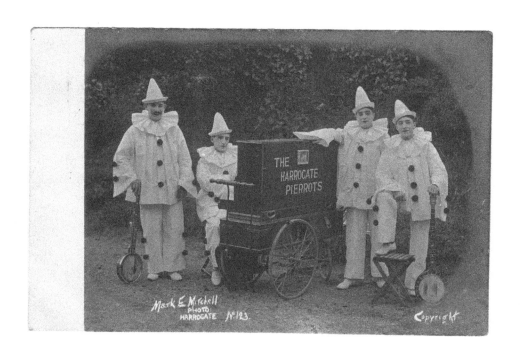

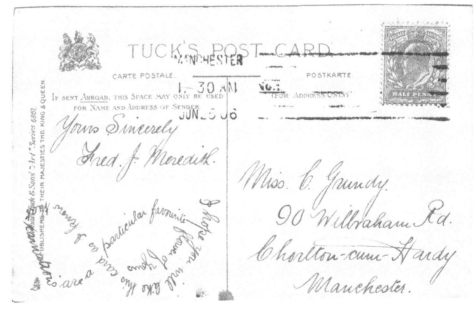

TUCK'S POST CARD

MANCHESTER

1.-30 AM

JUN 25 06

CARTE POSTALE

POSTKARTE

If sent Abroad, this space may only be used
for Name and Address of Sender

(FOR ADDRESS ONLY)

HALF PENNY

Yours Sincerely
Fred. J. Meredith.

Miss E. Grundy.
90 Wilbraham Rd.
Chorlton-cum-Hardy
Manchester.

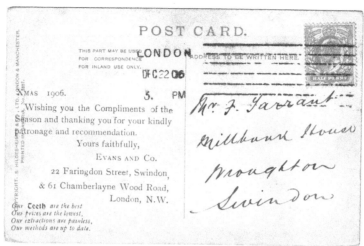

POST CARD.

THIS PART MAY BE USED
FOR CORRESPONDENCE
FOR INLAND USE ONLY.

LONDON
DEC 22 06
3. PM

XMAS 1906.

Wishing you the Compliments of the Season and thanking you for your kindly patronage and recommendation.

Yours faithfully,

EVANS AND CO.

22 Faringdon Street, Swindon,
& 61 Chamberlayne Wood Road,
London, N.W.

Our Teeth are the best
Our prices are the lowest,
Our extractions are painless,
Our methods are up to date.

Mr. F. Tarrant
Millbank House
Broughton
Swindon

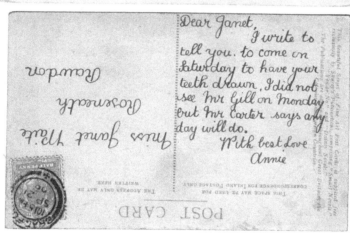

Dear Janet,
I write to tell you to come on Saturday to have your teeth drawn. I did not see Mr Gill on Monday but Mr Carter says any day will do.
With best love
Annie

Miss Janet Watt
Rosneath
Crowdon

POST CARD

POST ⚓ CARD.

For the British Isles only, THIS SPACE AS WELL AS THE BACK MAY BE USED FOR CORRESPONDENCE. (VIDE Post Office Regulations.)

THE ADDRESS ONLY TO BE WRITTEN HERE

Dear Madam
It was easy to disappoint you to day, but I have the face-ache & swollen very badly, but if you will let me know which day again I will oblige you.
E. Evans.

Mr Radcliffe
Pigeon House
Nr Ross-on-Wye

193

Mr & Mrs Towler request the
pleasure of the company of
Miss Jeannie & Mr Owen Davis
to tea on Sunday afternoon
and further desire them to
convey to Mr Davis their very
kind regards
 R. & R. E. Towler
241 Manchester Rd

Miss J. Davis
286 Ribbleton Lane
 Preston

Why Hannah Austin
as not attended School
she is leaving the Welshampton
the beginning of next week
I told Mr. Edward I
am Yours Truly
the childs Mother

Nr 11 Willow Street
 Ellesmere
 Salop

Dear Sue
Charl very much
worse but very
quiet he can
hardly get his
breath you or
Bill come if you
can Minnie

Mrs Bastable
18 Ryhl Street
 Kentish Town

POST CARD.

THE ADDRESS ONLY TO BE WRITTEN HERE.

Miss E. J. Hodgson
Heaton Manor
Hitchin
Herts

You know that buttonhook you gave me, well when I unpacked I could not find it, so perhaps the maid forgot to put it in. I left it in one of the top drawers. So would you mind bringing it on Tuesday

TUCK'S POST CARD.

(FOR ADDRESS ONLY.)

FOR POSTAGE, IN THE UNITED KINGDOM ONLY, THIS SPACE MAY BE USED FOR CORRESPONDENCE.

Mr L. J. Smith
Carlingcott Mills
Peasedown St John
N' Bath

Post Office
Camerton
16/5/06

Dear L/
Please send me up 2 sacks meal before dinner, quite out & oblige
Yours faithfully
E. H. Carter
in haste.

Raphael Tuck&Sons "SILVERETTE" (Regd) Postcard 6d 'Bristol'

195

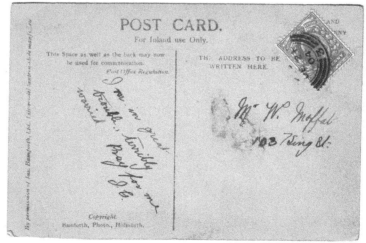

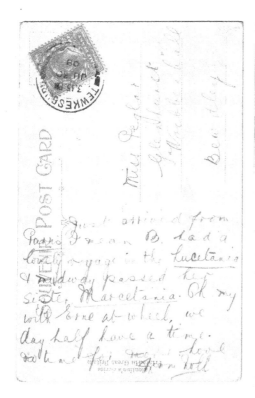 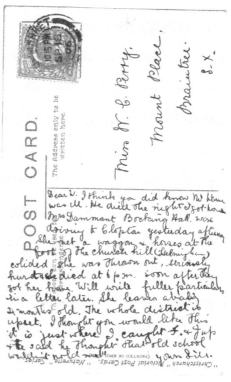

POST CARD

Miss Poplar
Glebhurst
...church Hall
Bewdley

Just arrived from
Paris. Mean B. had a
lovely voyage in the Lucetania
& midway passed her
sister, Mauretania. Oh my
will tell me at ..., we
day half have a time.
...

POST CARD.

The Address only to be
written here.

Miss W. C. Perry,
Mount Place,
Braintree.
S. X.

Dear W. I think you did know Mr Herne
was ill. He died the night & got her
Mrs Sammant Bocking Hall. was
driving to Clopton yesterday afternoon
She met a waggon & horses at the
foot of the church hill (Felmingham)
colided. She was thrown out, seriously
hurt & died at 6 p.m. soon after they
got her home. Will write fuller particulars
in a letter later. She leaves a baby
4 months old. The whole district is
upset. I thought you would like this.
It is just where I caught F. & I up
& he said he thought that old school
wouldn't hold ... Yours J.E.

"Christchurch" Pictorial Post Cards. "Naturette" Series

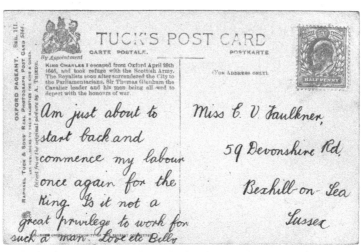

TUCK'S POST CARD

CARTE POSTALE.

POSTKARTE

By Appointment

OXFORD PAGEANT. Ser. III.

RAPHAEL TUCK & SONS' REAL PHOTOGRAPH POST CARD 3591

KING CHARLES I escaped from Oxford April 26th 1646, and took refuge with the Scottish Army. The Royalists soon after surrendered the City to the Parliamentarians. Sir Thomas Glenham the Cavalier leader and his men being allowed to depart with the honours of war.

(FOR ADDRESS ONLY)

HALF PENNY

Am just about to start back and commence my labour once again for the King. Is it not a great privilege to work for such a man. Love etc Bills

Miss E. V. Faulkner,

59 Devonshire Rd,

Bexhill-on-Sea

Sussex

POST CARD.

FOR INLAND POSTAGE THIS SPACE, AS WELL AS THE BACK, MAY NOW BE USED FOR COMMUNICATION.
FOR FOREIGN POSTAGE THE BACK ONLY
(Post Office Regulation)

THE ADDRESS ONLY TO BE WRITTEN HERE

Sir Please make me a pair of Box cloth Gaiters of a darker shade and oblige yours truly R. Gifford

C Morgan Esq
Tailor
Bank Buildings
156 & 157 Westgate St
Gloucester

POST CARD.

For Inland Postage only.
This space may be used for Communication

The address only to be written here.

HIGHBURY 5·30 PM JU 23 09

Jan A.
Dada dangerously ill gone to Hospital this after—
Will

Rev. A. F. Daniel
16 Gorge Park
Holloway
N.

198

TRANSPORT

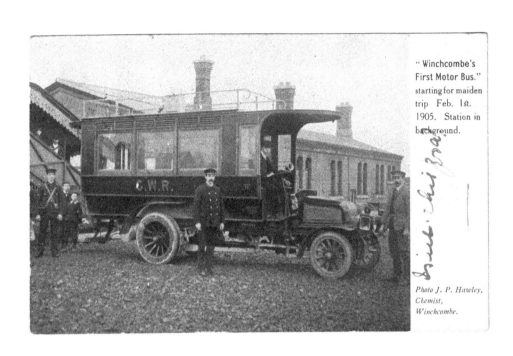

"Winchcombe's First Motor Bus." starting for maiden trip Feb. 1st. 1905. Station in background.

Photo J. P. Hawley, Chemist, Winchcombe.

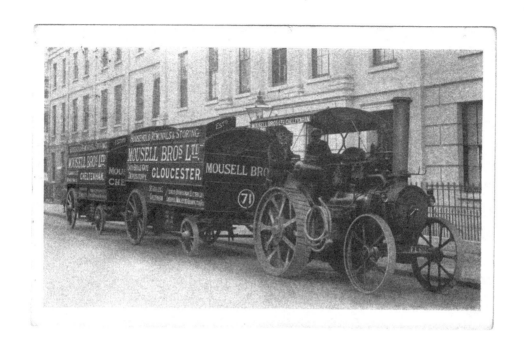

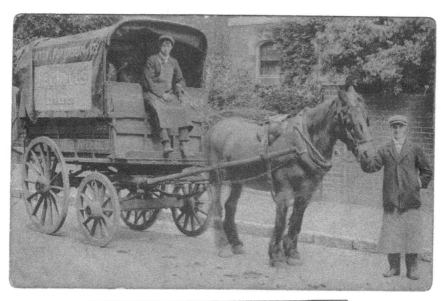

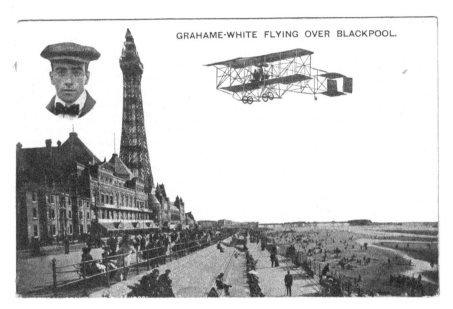

GRAHAME-WHITE FLYING OVER BLACKPOOL.

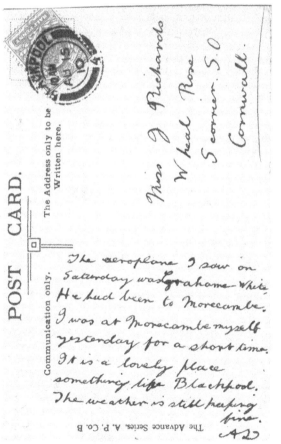

POST CARD.

The Address only to be
Written here.

Communication only.

Miss J Richards
Wheal Rose
Scorrier. S.O
Cornwall.

The aeroplane I saw on
Saturday was Grahame-White.
He had been to Morecambe.
I was at Morecambe myself
yesterday for a short time.
It is a lovely place
something like Blackpool.
The weather is still keeping
fine.
A2

The Advance Series, A. P. Co. B

203

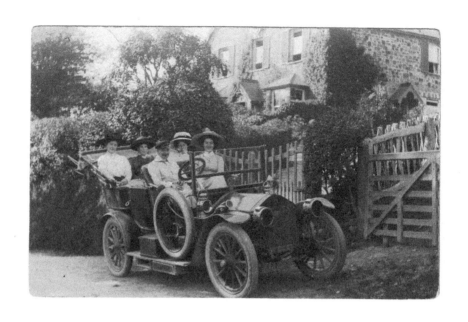

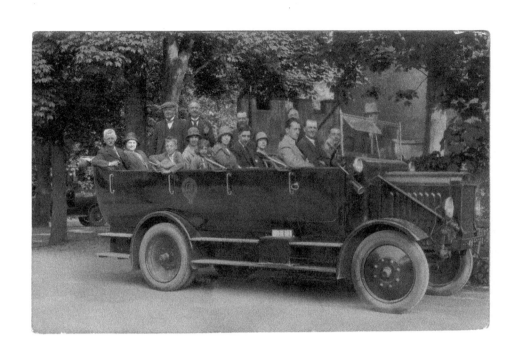

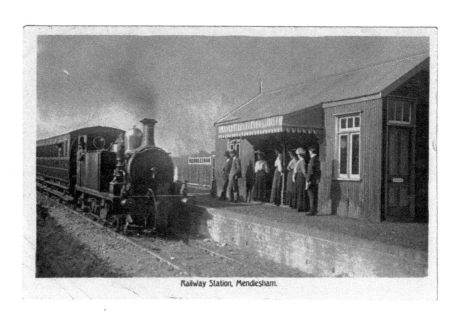

Railway Station, Mendlesham.

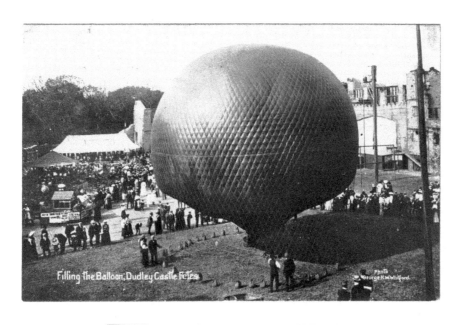

Filling the Balloon, Dudley Castle Fetes

Dear Auntie a Post-
card for you at last
but I have been very
upset as mother as
had a little son
she had it last
Saturday but the
baby is dead buried
it Thursday only
lived three days
but I am very pleased
to tell you Mother
is going on very
well indeed. We
all hope you are
better send you a
letter soon love from
Maud xxxxxx

Miss E. Wilcox.
816. Mrs. Masters
13 arch H.
Ewell.
Surrey

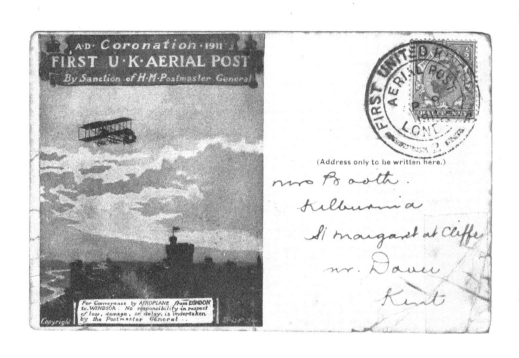

A·D· Coronation ·1911
FIRST U·K· AERIAL POST
By Sanction of H·M· Postmaster General

For Conveyance by AEROPLANE from LONDON to WINDSOR. No responsibility in respect of loss, damage, or delay, is undertaken by the Postmaster General.

Copyright

(Address only to be written here.)

Mrs Booth.
Kilburnia
St margaret at Cliffe
nr. Dover
Kent

INSTRUCTIONS.
Cost of Postcards, Stamped : Inland, 6½d.
Envelopes, Stamped (containing special note paper) : Inland, 1.1.
Adhesive Stamps must be affixed to make up the fee required for postage abroad.
Where to Purchase and Where to Post :
Army and Navy Stores, Arding & Hobbs, John Barker, John Barnes, Benetfinks, D. H. Evans, Gamages, Harrods', London Aerodrome, Selfridges, Whiteley's, and General Buildings, Aldwych
CAUTION.—Unless posted in the SPECIAL BOXES at the above establishments missives will NOT be conveyed by Aerial Post.
For Date of Termination of Aerial Post and further information see general notice on the Special Post Boxes at the above establishments, also Daily Press.
Sole Wholesale Agents :
P. C. Burton & Co., Ltd., GENERAL BUILDINGS, ALDWYCH, W.C.
Profits of Aerial Post

(This space for written or printed matter.)

I don't know whether this will go by aeroplane but I am going to post it in the aeroplane box. hope you are both quite well. I shall not be down till 24th again Please thank father for his letter. Have shown mr matz the part about the old Dickensian
Love

208

POST CARD.

For INLAND Postage this Space, as well as the Back, may now be used for Communication.

THE ADDRESS ONLY, TO WRITTEN HERE.

Kindly meet
Nothm train due
at 9. 4 tomorrow
night (Wednesday
& oblige
A. Adlington

Mr George Baines
Cab Proprietor
Mansfield
Notts.

POST CARD.

PRINTED IN GREAT BRITAIN

For INLAND Postage only this space may be used for communication.

The Address only to be written here.

Stranded 13 miles this
side of Derby. Shall
be lucky if we get in CB
by midnight Sunday. Had
two punctures & one burst
tyre. also hot water pipe
bursted. Tired out
 love from all.
 Digger.

Mrs Doggett.
H. Dean Rd
Liverpool

209

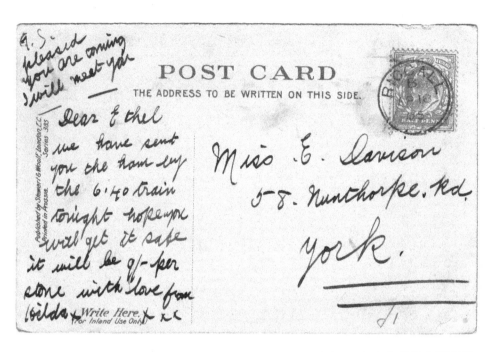

P.S.
pleased
you are coming
I will meet you

Dear Ethel
we have sent
you the ham by
the 6.40 train
tonight hope you
will get it safe
it will be 9/- per
stone with love from
Hilda

POST CARD
THE ADDRESS TO BE WRITTEN ON THIS SIDE.

Miss E. Davison
5-8. Nunthorpe. Rd.
York.

POST CARD.

FOR COMMUNICATION. FOR ADDRESS ONLY.

Dear Sir
Can you reserve for
us 5 Seats 3rd class
in a through compartment
on the London bound
Train on Monday next. I
think it leaves Minehead at
6.50. Yours faithfully, F. Thompson

The Station Master.
Minehead

SUFFRAGETTES

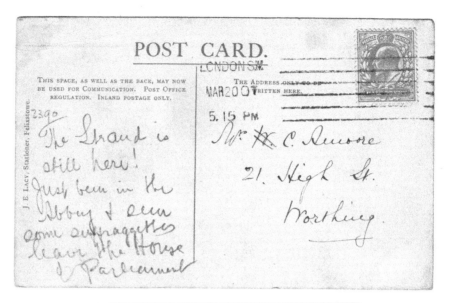

POST CARD.

THIS SPACE, AS WELL AS THE BACK, MAY NOW
BE USED FOR COMMUNICATION. POST OFFICE
REGULATION. INLAND POSTAGE ONLY.

THE ADDRESS ONLY TO BE
WRITTEN HERE.

LONDON S.W.
MAR 20 07
5.15 PM

J. E. Lacy, Stationer, Felixstowe.
2390

The Grand is
still here!
Just been in the
Abbey & seen
some suffragettes
leave the House
of Parliament

Mr. H. C. Amore
21. High St.
Worthing.

POST CARD.

The ADDRESS ONLY to be
Written Here.

For Inland Postage ONLY this space may
now be used for Communication.

Published by PICTORIAL CENTRE, 7 GRAND JUNCTION ROAD, BRIGHTON
No. 40. (Copyright)

Mrs M. Willis.
12 High St.
Biddulph,
Congleton.

Penkridge.
16/8/11.
Dear M.
Thanks for P.C. Hope
you have had a good
time. I have been to
Stoke for the week-
end. Suffragette
meeting here last night,
quite a crowd out.
Love from Amy

212

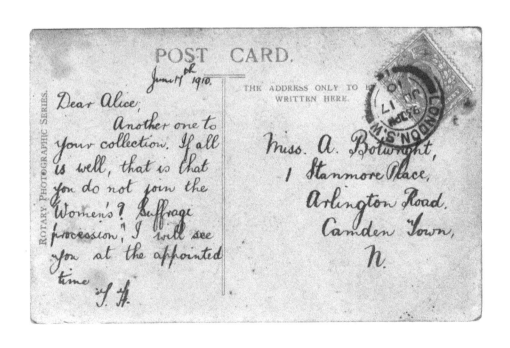

TUCK'S POST CARD

CARTE POSTALE

POSTKARTE

By Appointment.

(FOR ADDRESS ONLY.)

N.B.
Your Bright Smile
Haunts me still

July 3rd 1909

"CANTERBURY CATH

"OILETTE" Postcard 7021

Raphael Tuck & Sons

ART PUBLISHERS TO THEIR MAJESTIES THE KING & QUEEN

Painting by C. E. FLOWER.

The Baptistery. Since A.D. 597, when St. Augustine landed in Kent, the site on which Canterbury Cathedral stands has been occupied by a Christian church. The present structure dates from 1070, when the old Saxon church was rebuilt by Lanfranc. The Baptistery, or "Bell Jesus," is an old piece of work off the north-east transept, and leading from the Presbytery to the old monastery buildings.

Dear Katie

After 8 years slept in this
Ancient City. "Vote for
Women". I've rolled about
the last ten nights on a
Spring Mattress — My first
Bell to the House of Lords will
be for Feather Beds to be
supplied to every Workhouse in
the united Kingdom. I don't mean
to be done out of my "Old age Pension"
A Feather Bed means a "Dream of Paradise"...!!!
a Spring Mat—" means Toothache Neuralgia & Gout rolled into One.
Well love Ell.

Miss K. E. Beaujeu

12 Cleveland Mansions

Elgin Avenue

London

W.

POST CARD.

June 17th 1910

THE ADDRESS ONLY TO BE
WRITTEN HERE.

ROTARY PHOTOGRAPHIC SERIES.

Dear Alice;
 Another one to
your collection. If all
is well, that is that
you do not join the
Women's? Suffrage
procession, I will see
you at the appointed
time
 J. H.

Miss. A. Boltwright,
1 Stanmore Place,
Arlington Road,
Camden Town,
N.

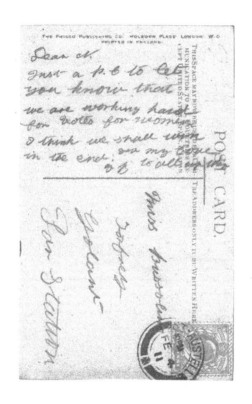

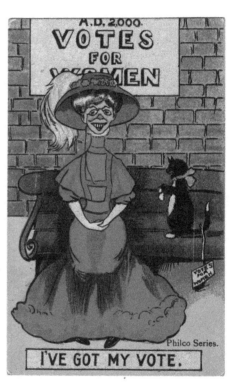

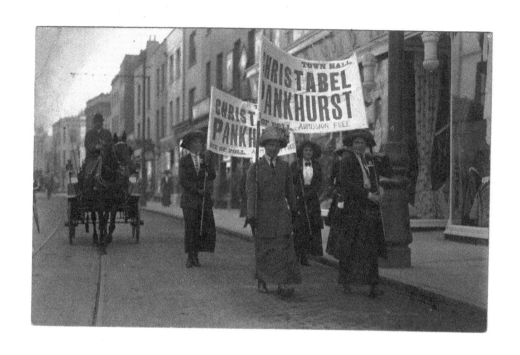

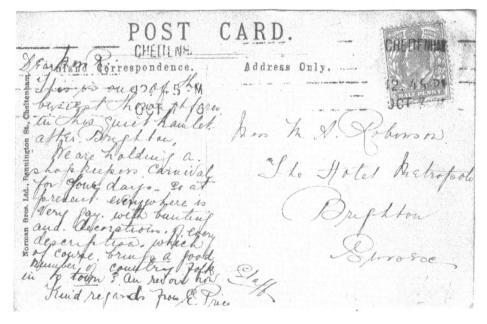

Lightning Source UK Ltd.
Milton Keynes UK
UKHW051428040522
402466UK00005B/151

9 781802 273519